NEWQUAY
THROUGH TIME
Sheila Harper

AMBERLEY PUBLISHING

About the Author

Sheila Harper has been an active member of the Newquay Old Cornwall Society for over thirty years. She is joint author of *Images of England Newquay* with the late Joyce Greenham, first published in 1999. She has written local history articles for newspapers and was involved in the research for the River Gannel trail and the Discover Newquay Map. She is the NOCS Local Warden of Ancient Monuments. Her hobbies are mineralogy, birdwatching, archaeology and writing.

To the late Joyce Greenham, Bard Lowena Lywans
and 'gatherers of fragments that nothing be lost' everywhere.

First published 2013

Amberley Publishing
The Hill, Stroud, Gloucestershire, GL5 4EP
www.amberley-books.com

Copyright © Sheila Harper, 2013

The right of Sheila Harper to be identified as the Author of this work has been asserted in accordance with the Copyrights, Designs and Patents Act 1988.

ISBN 978 1 4456 1317 8 (print)
ISBN 978 1 4456 1326 0 (ebook)

British Library Cataloguing in Publication Data.
A catalogue record for this book is available from the British Library.

Typesetting by Amberley Publishing.
Printed in Great Britain.

Introduction

The history of Newquay began around 10,000 years ago when hunter herders arrived here. We find their flint tools and toolmaking waste in Newquay eroding out of ancient land surfaces.

By around 6000 BC, large stone chamber tombs, or quoits, were being erected. We have no surface remains of these, but stone axes, flint tools and rubbish tips of discarded shells do turn up from that period. From around 2200 BC bronze, a mixture of tin and copper, was used for tools. There is evidence at Treloy of stones and gravel rich in tin ore being dug out of the riverbed then by the process of tin streaming. Also, large mounds called barrows were being built. Many still remain along our coast. Later, roundhouse villages and their fields began to occur, as discovered at Trethellan Farm in 1987 where a Middle Bronze Age site was excavated. Newquay's best survival from the Iron Age is Porth Island, with finds dating from around 800 BC. Where there have been no excavations, field names give us a clue. Could Killacourt be 'Killa's Quoit'? We have Berry Road named after a nearby field, which has now been built upon. Berry is said to imply 'Bury', which means a fort or castle. Iron Age farms consisted of houses surrounded by a huge wall, the remains of which could look like a castle.

By medieval times, we have the written record. The Manor of Towan Blystra, the seed from which Newquay grew, existed in 1439. There was a little village around Central Square and a nearby harbour used by traders and fishing boats principally catching pilchards. Farms existed with their characteristic strip fields, and some of these can still be seen from Trevenson Road. In a nearby manor, tin streaming took place and, around 1465, William Tregheur and Mark Trewasek got in trouble for 'blocking the water between Treloy, Trewassick and Caskeys'. Lead was also being mined. In 1579, Capt. Fenton sent a letter to the Privy Council containing 'silver ore', which had been found in 'a silver work of Burcotts at New Kaie hard by the sea'. The silver must have been extracted from lead ore from a local mine.

By the early 1800s, handwork was being replaced by machinery and there was a need for raw materials that included metal and stone. Around Towan Blystra, there were still working lead mines and tinworks. J. T. Treffry of Place at Fowey saw potential to make money and he bought the Manor of Towan Blystra, including the town of Newquay, in 1838.

He began developing Newquay Harbour to ship out china clay and ore. He needed a railway to do that, and by 1844, he had a horse-drawn line with links to his clay pit at Hendra and his lead mine at St Newlyn East.

He had plans to develop a larger harbour at Towan Head, also planning to extend his railway to reach there, but he died in 1850 before the work was completed. Ever the businessman, he envisaged a growing town and sold off land for housing. Already Newquay was seen as a watering place for the gentry, and large houses were popping up on select sites overlooking the sea. An infrastructure began to develop to cater for a growing population, including building a parish church in 1858. Then, in 1876, the railway was able to carry passengers. That gave further impetus to growth, and Newquay began to expand into the modern town it is today.

Acknowledgements

The work included here is part of ongoing research and there is still much to be done. Some of the information given is anecdotal or from notes written on the back of old photographs and in documents, so I beg forgiveness if I have made errors. You, the reader, I hope will contact me and correct these. Many Newquay people, both past and present, have helped with this book, sometimes unwittingly. I would like to offer my sincere thanks to all of you and my humblest apologies to those I have omitted.

Andy Boxall – owner of *Hockins Brochure* (page 72)
Bartlett, John, *Ships of North Cornwall*
Gray, Betty, *Oh My Dear Life*
Hamilton-Jenkin, A. K., *Mines and Miners of Cornwall, Pt. 8, Perranporth to Newquay*
Harper, Sheila and Joyce Greenham, *Images of England Newquay*
Homeland Handbook of Newquay 1909 (page 31)
Kelly's Directory 1907, 1915, 1939
Lukes, Wilfred J., *Old Newquay*
Newquay Old Cornwall Society, *Newquay's Pictorial Past* (*c.* 1980)
Newquay Old Cornwall Society archive: documents by the late Mr Cresswell Payne, Mr G. White, Mr E. J. Ennor, R. Gillis, Mr Chugg; Treffry Mineral Railway Harbour Plan, 1840 Tithe map
Newquay Old Cornwall Society members: Norman Bailey, Chris and Hilary Borkett, Peter Hicks, Denise Marshall, Mervyn Mitchell, Rachel Parry, Richard Prestige, Len Sheppard, Chris Shinner, Moira Tangye
Newquay Old Cornwall Society website
Penhallurick, Roger, *Mining in Antiquity*
Roger Jenkin: corrections on *Images of England Newquay*
Sheila Harper and Steve Hebdige, Local History archive
Stan May: railway information
Teague Husband, S., *Old Newquay*
Vaughan, John, *The Newquay Branch and its Branches*
Ward Lock Guide, Newquay and North Cornwall, 10th Edition
Woolf, Charles, *Newquay Old Cornwall Society: Fifty Years of Events Personalities and Records*
Young, Stuart, *History of the Hotel Bristol*

Online resources: The Happy Pontist blog, Cornwall Online Parish Clerks, Heritage Gateway, Genuki

Photographs: NOCS Collection including the Woolf/Greenham Collection and R. P. Hirst (pages 11, 12, 13, 15, 16, 17, 18, 19, 20, 21, 22, 23, 24, 28, 29, 35, 37, 49, 51, 52, 53, 54, 56, 57, 59, 60, 61, 62, 65, 66, 67, 68, 69, 70, 73, 75, 76, 77, 82, 84, 87, 90, 93, 94, 95)
Postcard Collection of Alan Foxall and Steve Hebdige

Early Times

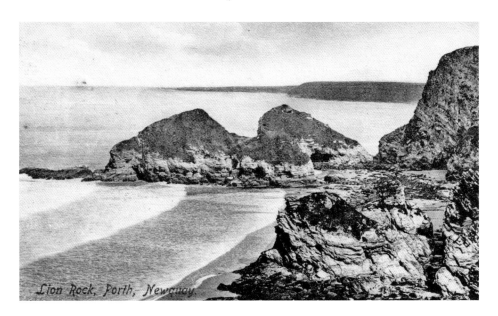

Lion Rock, Porth, Newquay.

Lion Rock

Erosion by the sea has led to the formation of sea stacks that catch the eye because of their shapes and become landmarks such as Lion Rock, found separating Whipsiderry and Watergate Beaches. On the map, it is part of a group known as Zacry's Islands. Perhaps earlier visitors to Cornwall saw some importance in this part of the coast, as above these rocks on top of the cliff are two huge burial mounds, which are at least 4,500 years old. On excavation, one of these yielded many barrow-loads of burnt earth, which indicates that a fire burnt on the top of it for many weeks. This would have been seen for miles.

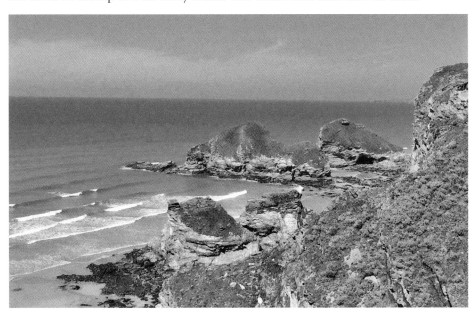

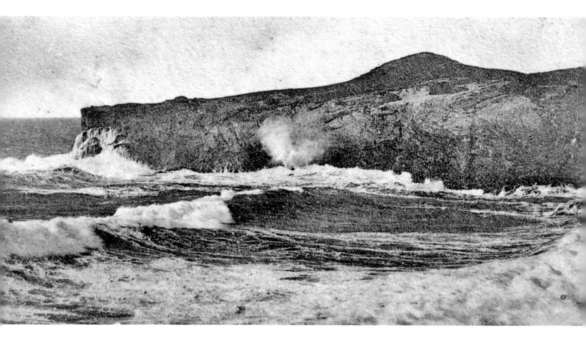

Trevelgue Head

With a great boom in the right tidal conditions, the blow hole in the cliff at Trevelgue Head, also known as Porth Island, gives a great performance. Watching and photographing it in action has been a popular pastime for many years. The early postcard picturing it was produced before 1903. Porth Island is of interest to the archaeologist. As a result of erosion, flint tools from around 6,000 years ago are now visible on many of the paths. There is a large Bronze Age barrow present and the banks and ditches of an Iron Age trading post. In the Iron Age over 2,000 years ago, people were smelting iron ore there and trading it. The remains of their houses and tons of waste iron slag were discovered during excavation in 1939.

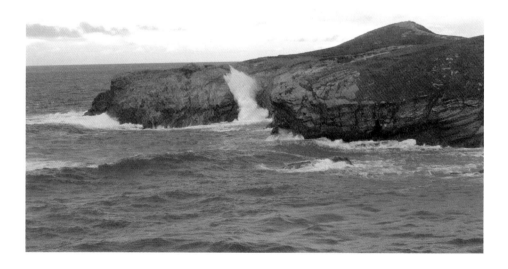

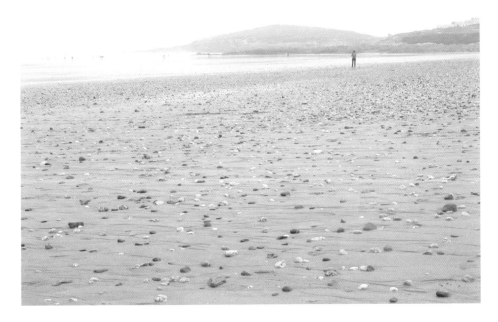

Fistral Beach

Popular with surfers and holidaymakers, Fistral Beach usually has lots of golden sand covering it. In October 2005, the sand was scoured away by strong winds and revealed many thousands of pebbles. These are visible, when conditions are right, in a 120,000-year-old former beach level in the cliff at the south end of the bay. Among the stones are flint cobbles, which provided a source of tool-making material in prehistory for people in the area at that time. Flint blades knocked off a pebble, depending on their length, width and thickness, can be made into many different types of tools. The one pictured, found on Trevelgue Head, has sharp edges and a point, and could be used as a spearhead for fishing.

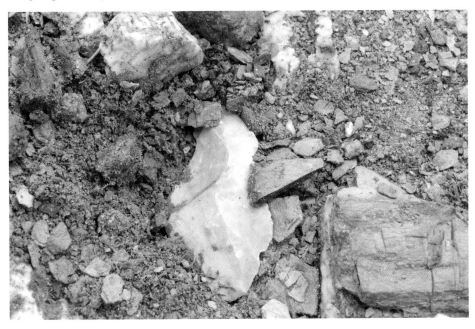

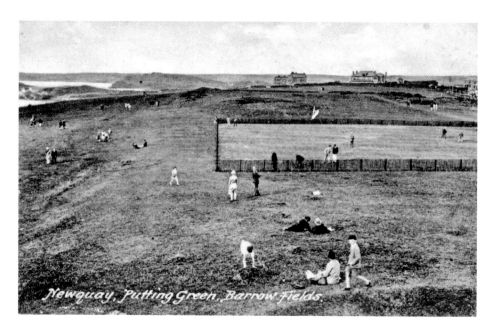

Newquay, Putting Green, Barrow Fields.

The Barrowfields

With views over Newquay's beaches, the Barrowfields is a very pleasant place to go putting. What people may not realise is that they are playing on a Bronze Age cemetery. The far left corner of the putting green bites into a Bronze Age burial mound, also known as a barrow. There is another visible at the south end of what were fields farmed by Mr Cardell in the nineteenth century. There were at least fifteen barrows on the site. A report to the Royal Institution of Cornwall in 1840 describes the destruction of one of them. Much of the barrow soil had been carted away for manure before Revd Canon Rogers, a noted antiquarian, could excavate it (with hired help, I might add). At the base of the barrow, he found burnt earth and yellow clay and a few broken flint blades, which might have been arrowheads. Digging a new trench, a 5-foot-high pile of stones with burn marks on them was discovered. Then the reverend noticed a pottery urn placed upside down on a piece of slate. It was filled with human bones, 'which at first appeared as white as snow'. He doesn't say what happened next to the bone, but it likely disintegrated due to exposure to the air. The stones probably ended up in local walls.

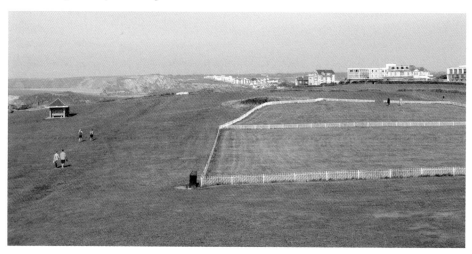

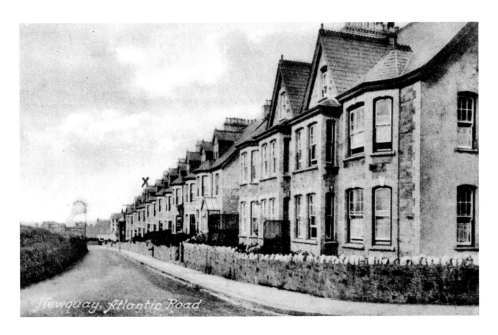

Atlantic Road

Stone from the disused engine house of Chiverton Wheal Rose Mine, at Trethellan on East Pentire, was said to have been used in the construction of some of the houses in Atlantic Road. The terraces were built over a few years from around 1909. In 1911, a Bronze Age cist was found. This was a box made of six stone slabs, in which a skeleton would have been placed. The slabs were taken to the new church, St Michael's at Marcus Hill. In the 1950s, when roadwork was being done, more bones were found and buried in the hedge facing the houses. In 1998, an archaeological dig, run by Ann Reynolds within the grassland across the road from the houses near the entrance of Atlantic Road to Pentire Road, revealed a Late Iron Age and Romano-British site.

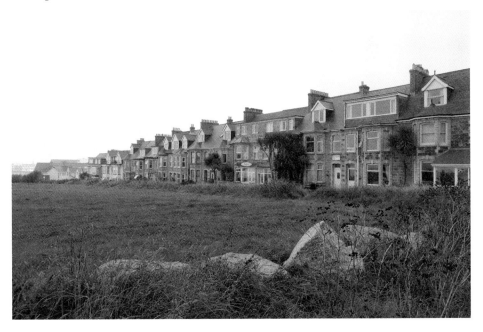

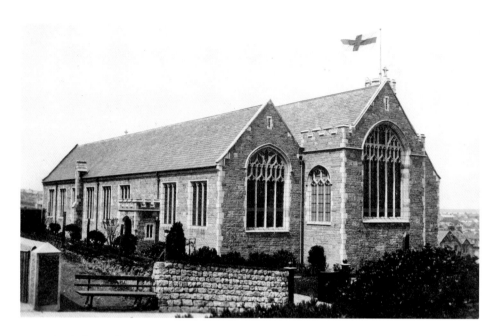

St Michael the Archangel Church, St Michaels Road
Designed by Sir Ninian Comper, building works for the church started in 1909. The tower was added in 1967. Some years ago, the author found the reference to stones from the Bronze Age cist discovered in Atlantic Road, during the construction of houses there, being taken to St Michael's church. She telephoned Peter Hicks, a well-known local historian and member of St Michael's congregation, about the stones. He told her where they were. The author rushed down to the church and found the two stone slabs pictured leaning against the wall of the memorial garden. They measure about 60 to 70cms in diameter and would be totally suitable for use in a Bronze Age burial chamber. There are other pieces of stonework at the memorial garden, likely to have come from the old chapel of ease that used to be in Bank Street.

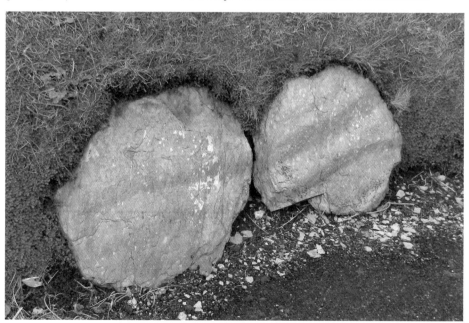

East Pentire Point

Stretching out into the sea is the East Pentire headland. On one side is the River Gannel and a view of Crantock, and on the other the Atlantic Ocean. On the Gannel side there is a large quarry, which provided stone for hedging, roads and buildings. The land was part of Pentire Farm and on old maps a large part of it was called The Warren. In 2010, the East Pentire Action Group got the headland designated as a 'Town or Village Green'. This means it can never be built on. At the far end of the path where the land rises up is a Bronze Age barrow, one of three on the headland. The trio form a triangle, and it is likely that the whole area between them would have been treated as a ritual landscape thousands of years ago. Like other barrows mentioned, these barrows can be seen from the sea and must have existed as a landmark for purposes we can only guess at.

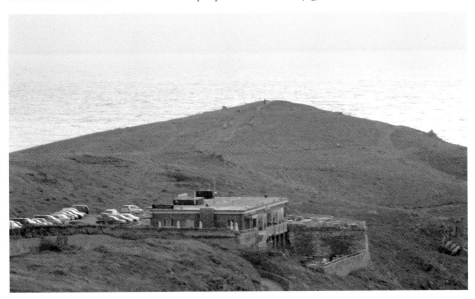

Seafaring

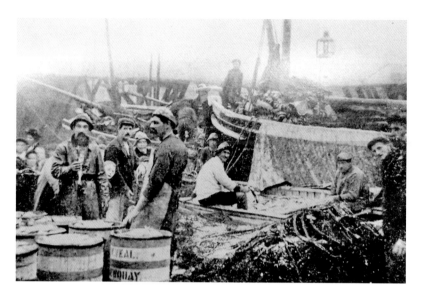

Fishing

Many people associate Newquay with pilchard fishing, but other fish played a part in the town's economy. Gone are the days of scenes like this bumper catch of herring being processed at Newquay Harbour. The fish were caught using drift nets, as is done today, and brought into harbour. The catch was transferred ashore and packed in barrels with salt for sale elsewhere. The *Charlotte Louise* is an example of a modern local boat. It is equipped to do potting for crabs and lobsters, netting flat fish like ray and plaice and hand-lining for pollock and bass. Here, her master, Chris Martin, is cleaning out after a day on the sea, the seagulls after the scraps.

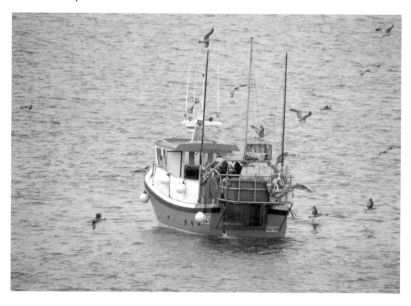

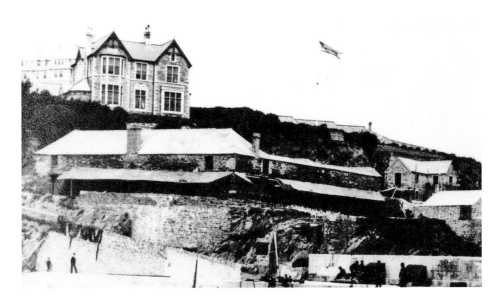

Active Fish Cellar

Pilchards needed pressing in layers with salt to remove their oil. They were then packed into barrels for export. The work was mostly carried out by women. The pressing was done in the fish cellar. The oil, called train oil, could be sold as well. There is a record of the Active existing in the eighteenth century. The pilchard industry began to decline in the late 1800s. In 1896, the cellar ceased use. At the time, it was being used as an artists' studio. Eventually, the town council acquired the site and built the Active Promenade and shelter. The flag on the flagpole above the Active Cellar reads 'Pentowan'. In the modern photograph, there is still a flagpole present and Pentowan House is still extant. This was the home of Sir Hugh Protheroe Smith, Chief Constable of Cornwall. In 1913, Prince Henry, Duke of Gloucester, and his brother George, Duke of Kent, stayed with him when they were recovering from whooping cough.

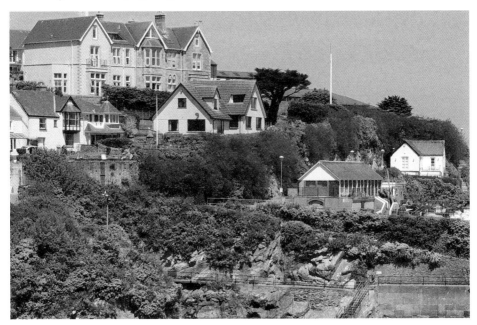

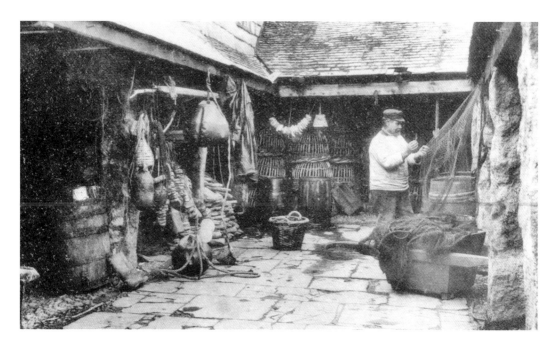

Nets and Pots

Caring for nets was a laborious task. Despite being steeped in preservative, as they were made of natural fibres they would rot easily so had first to be laid out in the open and dried after use. Afterwards, they might need repairing. This was done with a knotting technique like macramé. Modern nets are made of artificial fibres, such as nylon. The pots in the fish cellar are made of willow. Pots for crab, lobster and crawfish come in different designs, such as parlour pots, creels and keep or store pots.

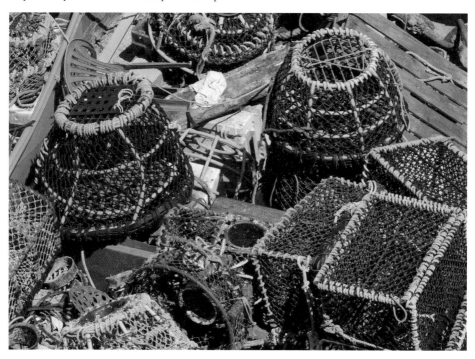

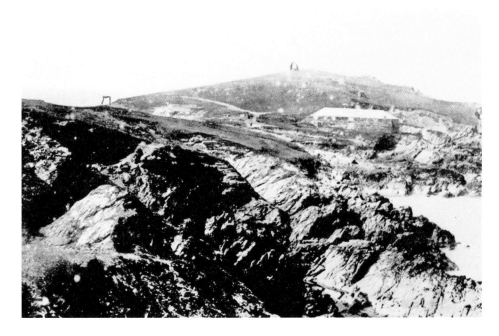

Spy Fish Cellar

On the eastern side of Towan Head are public conveniences. To one side of the building is a round structure, which is an old limekiln. Spy Fish Cellar was in front of this. It is said to be the oldest fish cellar Newquay had. The pencil marks on the old photograph, taken before 1899 when the cellar was built, show where the Old Lifeboat House and Coastguard's Lookout are today. The haul-way, where the pilchards were brought up to the cellar from the pilchard boat, still exists and here is being explored by members of the Newquay Old Cornwall Society.

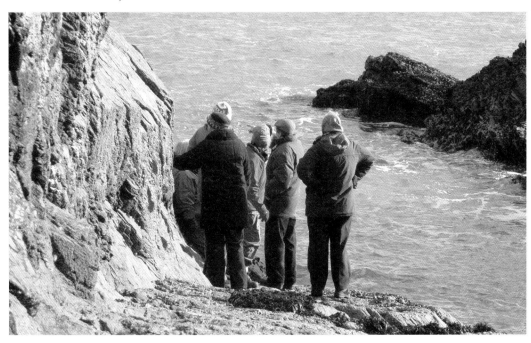

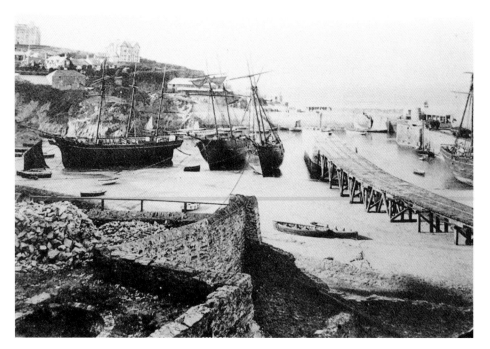

The Harbour Limekiln

The limekiln on the bottom left-hand side of the turn of the nineteenth-century picture shows it in use. Naturally occurring limestone rock was brought by ship to be turned into quicklime, which is calcium oxide. This was done by putting layers of crushed limestone with coal or wood in the top of the kiln and setting a fire underneath. At 900 degrees Celsius, quicklime would be formed. This was used for making mortar for building works, such as the expansion of the harbour walls, houses and as fertiliser for the land. When water is added to quicklime, a huge amount of heat is evolved, so it was not practical to transport it by sea! The boat in the modern picture is positioned in the kiln in the place where the fire was set.

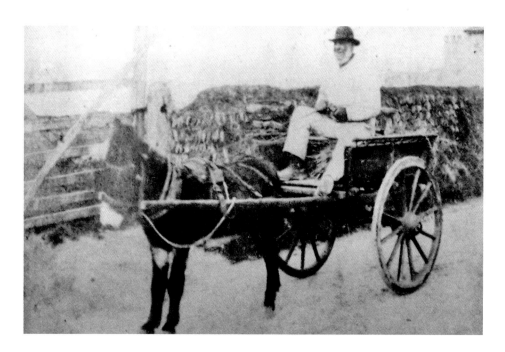

Fish Merchants

George Dungey was a Newquay 'Fish Jouster' and would sell his herrings and pilchards and other fish fresh from the harbour around the villages. Each jouster had a distinctive cry to summon up customers. George's photograph was taken about 1900. Today, we get our fresh fish from E. Rawle & Co. in East Street, run by a local Newquay born-and-bred family.

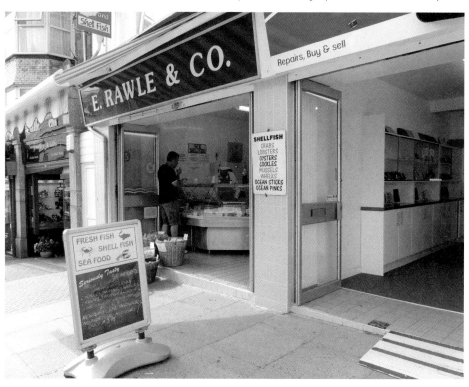

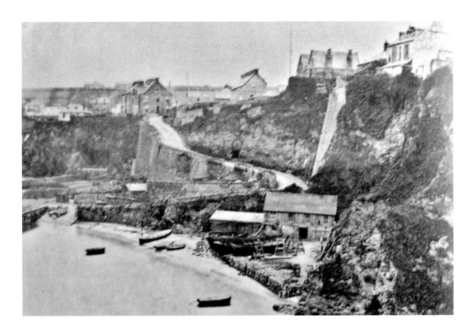

Below South Quay Hill

Quay Yard, below the road leading down to the South Quay, was established in 1849 by John and Martyn Clemens. Schooners such as the *Kitty* and *Forest Deer* were built here. Eventually, a general shipwrights' yard existed here into the early 1900s. It was still run by descendants of John and Martyn. Today, the Boat House restaurant is on the site. More buildings exist now below South Quay Hill, including the fine lifeboat house and adjoining chapel seen on the right of the modern picture. The low white building on the right where the road curves is the home of the Newquay Sailing Club, established in 1954. In the mid-1970s, the club hosted the National Mirror Regatta for the Mirror dinghy. The idea for this little boat's design came from Barry Bucknell, who was the BBC television do-it-yourself expert.

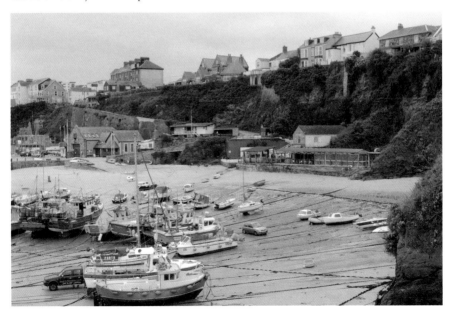

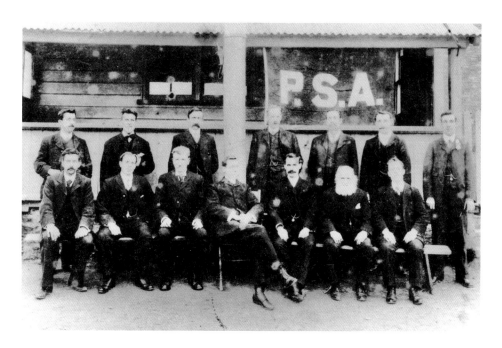

The Seamen's Shelter

The shelter was opened in 1891 as a place where seamen could come and read the newspapers, Christian literature and improving books. They could wear their working clothes in there. A missioner was employed and a Pleasant Sunday Afternoon (PSA) Christian service was held on Sunday afternoons. Known as the PSA or Harbour Mission, it carried on until 1992, when a larger lifeboat house was needed on the harbour. The RNLI needed the ground the shelter was on and offered to rebuild a new chapel. The Newquay lifeboat station is the only one in the world with a chapel attached to it.

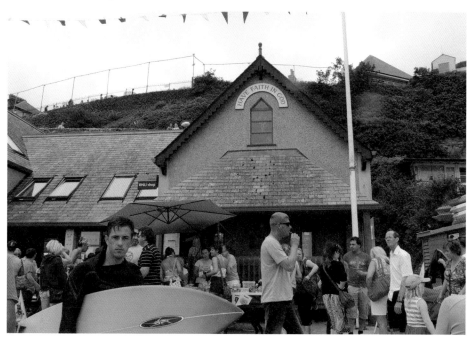

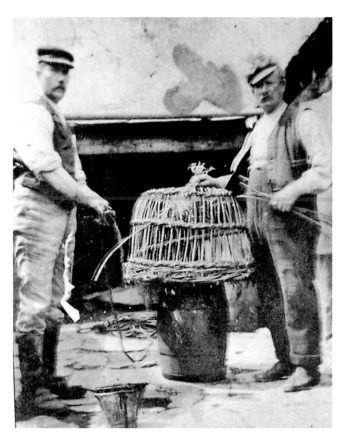

Crab Pot Making

If you walk down South Quay Hill and look down over the wall towards the Harbour Restaurant, you will see tanks containing lobsters and crabs. The claws of the lobsters have elastic bands round them to stop them attacking each other. In early days, crabs and lobsters were caught in willow pots. The pots were made in the winter or when the weather was bad, ready for the fishing season. Green willow was used in their construction.

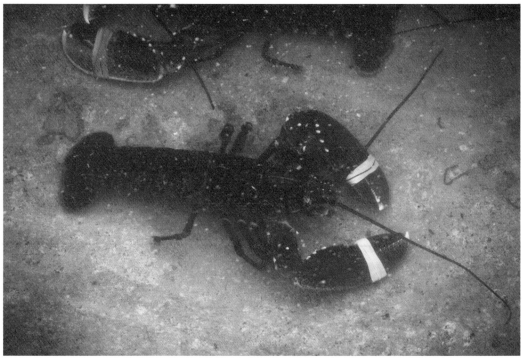

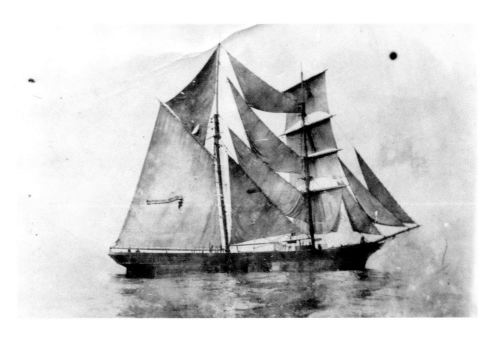

The *Mary Ann* and the *Blythe*

Cargo, such as coal, limestone, timber and grain, was brought to Newquay by ship. Exports from the harbour, especially in the nineteenth century, included china clay, lead and iron ore. These were carried in vessels like the *Mary Ann*. Built in 1879, her master from 1910 onwards was Capt. T. Hicks of Newquay. On sail from Brittany to Swansea in 1917 carrying pit wood, she was attacked by a German submarine. She stayed afloat because of her cargo of timber and got towed to Guernsey. F. J. Hubert purchased her there. Sadly, she did not outlast the First World War. Now Newquay Harbour is manned by small fishing boats and boats for recreational purposes. The catamaran, the *Blythe*, is a charter boat working out of Newquay, mainly carrying people out to do diving off wrecks.

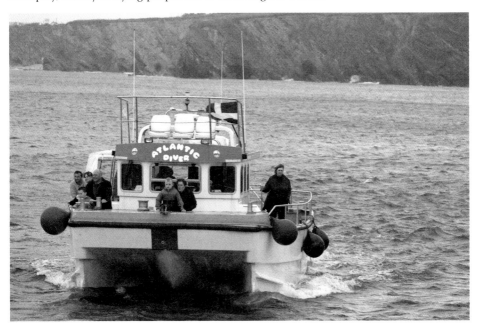

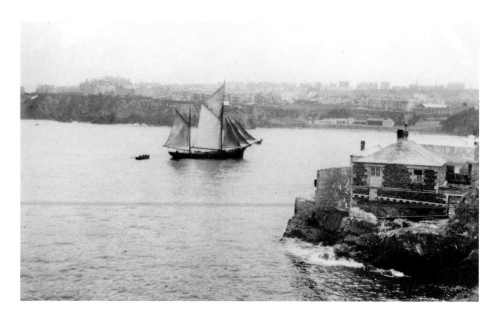

The *Vixen* and the *Fly*

Sailing into harbour, passing the Fly Cellar on the right, is the *Vixen*, built in 1870 at the Island Cove Yard at Towan Beach, and has a hobbler's boat in attendance. The hobblers' boats were used for manoeuvring ships in and out of harbour and managing lines and buoys. On the River Gannel, there was a shipyard and boats built there had to be launched broadside on into the river. The hobbler boats would then tow the ship up the Gannel round to the harbour to be fitted out. Pilot gigs also directed shipping. A gig is a fast, ocean-going rowing boat. Gig racing was a pasttime in the nineteenth century but then fell in and out of favour. In 1921, Newquay Rowing Club started up. There were still three gigs in race-worthy condition: the *Newquay*, built in 1812; the *Dove*, built in 1820; and the *Treffry*, built in 1838. They still exist today. They race against other clubs in Cornwall and the Isle of Scilly. Gigs are still being made. Pictured is the *Fly*, built in 1993 by Ralph Bird, on a training run out of the harbour.

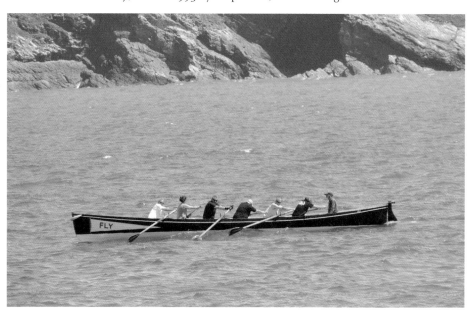

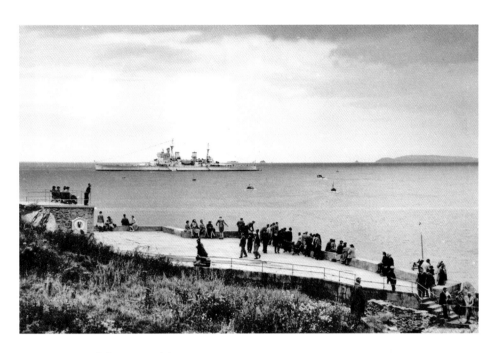

HMS *Howe* and the *Tamarisk*

After the Second World War, HMS *Howe*, a King George V class Royal Navy battleship, became the flagship of the training squadron at Portland. Here, she is visiting Newquay on 4 August 1947. HMS *Howe* was launched in 1942 and did much service in the war, including providing gunfire cover for the allied landings at Okinawa in 1945. By contrast, the *Tamarisk* has never seen enemy fire. She provides pleasure boat trips out of Newquay Harbour. This includes putting out fishing lines off the back of the boat to catch mackerel. Passengers on the boat can take the fish home if they want, but most end up being fed to seals in the harbour. One is just having a look for a treat on the wrong side of the boat.

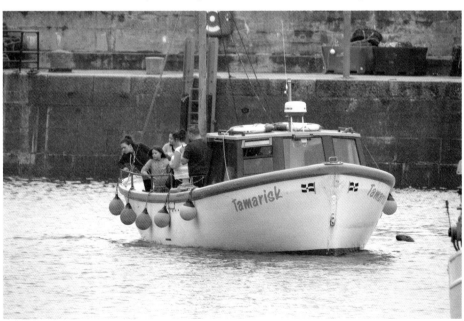

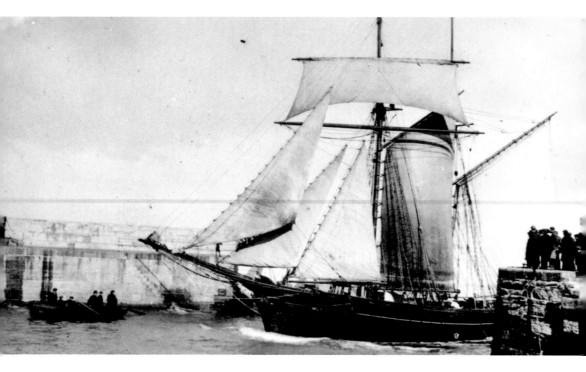

The *Fairy Maid* and the *Island Maid*

Carrying coal, the *Fairy Maid* sails gracefully into Newquay Harbour. She was built at the Gannel Yard in 1876 and sadly finished her career wrecked on rocks near Holyhead in 1919. For a complete contrast, we have the pleasure boat, the *Island Maid*, also coming into harbour.

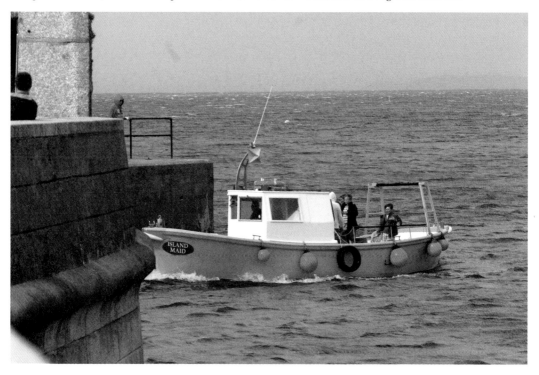

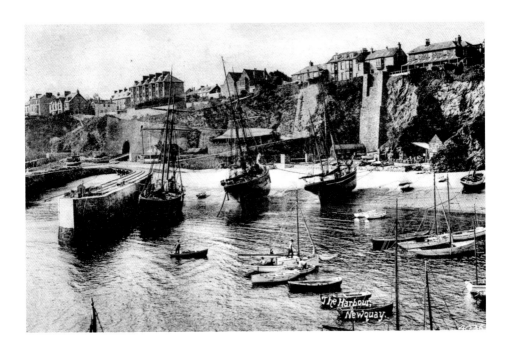

Low Water in the Harbour

In 1872, the Cornwall Mineral Railway Co. erected the jetty seen on the left-hand side of the late nineteenth-century photograph. Rails on the jetty ran up the incline via the tunnel, and thence connected with Treffry's older horse-drawn mineral railway line, by then much improved. Trucks were winched up and down the incline by cable from a winding engine situated on what is now the Sainsbury's supermarket site. Treffry had plans for a deep water harbour but died before it was built. At times of low water, boats cannot get in and out of the harbour. In 2011, Newquay Community Network acquired funding to regenerate the harbour and provide a site where vessels can unload at low tide.

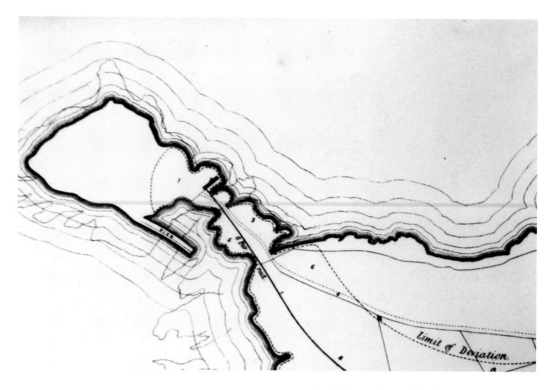

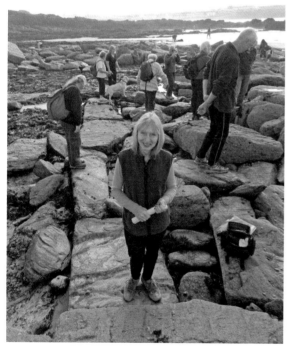

Treffry's Harbour of Refuge

Having bought the Manor of Towan Blystra in 1838, which grew into Newquay, Treffry began his plans to build a new harbour that would enable shipping to load and unload at any state of the tide. The first part of his plan was to build a harbour of refuge on the east side of Towan Head and run his mineral railway to it. The next part was to build a deep water harbour on the other side of Towan Head. Unfortunately, he died in 1850 and his dreams were never fulfilled. The extract from J. T. Treffy's map shows the harbour of refuge and the mineral railway line running up to where Spy Cellar was. He was also going to have water piped up to the headland, and was hoping to sell off land there for housing to finance his ventures. The harbour of refuge was started and work ceased on his death. Remnants of this harbour still exist, and the lower photograph shows members of the Newquay Old Cornwall Archaeological Group investigating what remains today.

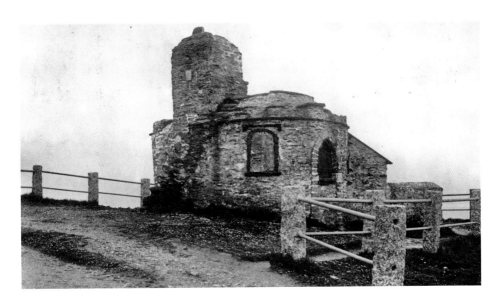

The Huers' House

There were a number of places on Newquay's coast where the huers would look out for the shoals of pilchards. There was a shed up on Trevelgue Head, for example. The only surviving look-out is the stone building pictured here on the Beacon near the Atlantic Hotel. It may date back to the fourteenth century. Originally, it was just a little round building. The forecourt was added later and other alterations made. In recent times, it was used as a public shelter, but now the doors and windows have been barred off. The huers' job was not just to spot the fish, but also to direct the proceedings during the time of fishing. They would also keep an eye on the weather and would call the fishermen in if a bad storm was approaching.

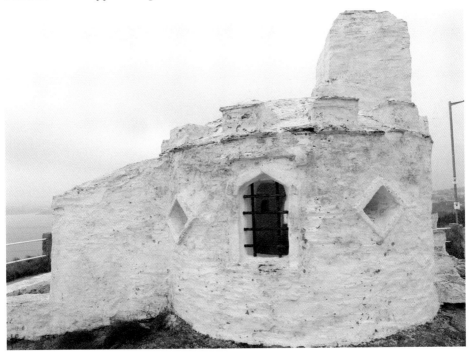

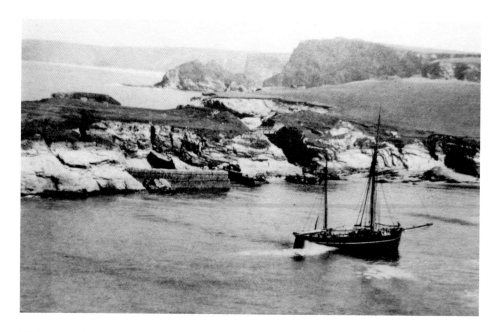

Vivian's Dock

In 1873, Arthur Pendarves Vivian purchased the Glendorgal estate above the west side of Porth Beach. He had a steam launch and had a dock built for it on the side of Trevelgue Head. He also tried to stop local people using Trevelgue. Local fishermen used the island as a look-out for the pilchard shoals and people walked the paths around Glendorgal for recreation. Vitriolic correspondence appeared in the newspapers in 1881 as Vivian destroyed ways up to the island and gated pathways on his land. The locals set up a petition against Vivian and a public meeting was held. Vivian sold Glendorgal to Sir Richard Tangye in 1882 and Porth inhabitants were glad to see the back of him. The dock was eventually dismantled and the stone used in building Trelawne, the new home for Mr Alex Stephens. Stephens was a ship owner and coal merchant at Porth.

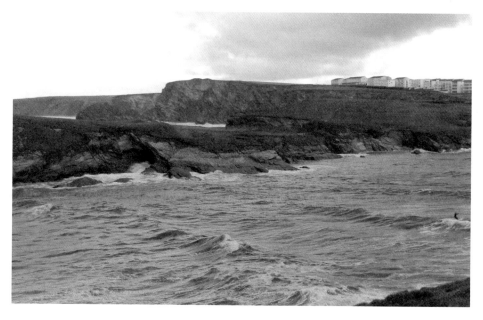

Mining

Local Mining

Most of the remains of mining in the Newquay area have been obscured by modern development. Tin streaming was the earliest form of obtaining ore for metal extraction. At Treloy Streamworks, on the river that discharges onto Porth Beach, a Bronze Age pin was found, and in 1830 a Romano-British bowl made of tin was discovered. Underground mining for lead and iron ore has left some traces, such as the adits in the cliffs behind Tolcarne beach, which belonged to Tolcarne Mine. On Mount Wise was the Newquay Silver and Lead Mine, also called Lehenver Mine. It has an adit outcropping at the back of Towan Beach, and water from it was used by the laundry and mineral water factory there. In 1996, there was a collapse into the mine adit at Killacourt and a big hole appeared, now marked by a flower bed. On Mount Wise, the shafts were behind the miners' cottages. At the back of the site was the shaft where James Pearce erected a windmill in 1889 to supply water to houses on Mount Wise. The windmill was later purchased by the water board and replaced with a pumping engine. Up a side lane by the cottages is the Newquay Water Works, built in 1894 and now used as a garage. Inside is another shaft capped by wooden boards. Water from here was used to supply the town. Now Newquay water is supplied from reservoirs away from the resort.

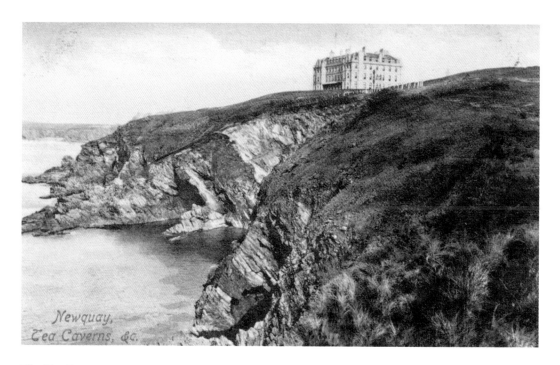

Newquay,
Tea Caverns, &c.

The Tea Caverns

Under cliffs crowned by the Atlantic Hotel and the War Memorial, the Tea Caverns are big caves down by the water's edge, so called as smugglers hid their booty in them ... or did they? No one will say. Hamilton Jenkin explored the caverns as a boy. The late George White, an active member of the Newquay Old Cornwall Society, told Hamilton Jenkin that they were probably connected to a shaft found between the roads to Towan Head and Fistral Beach. In Victorian times, one could hire a guide and be taken down a track to the caverns. These days they are visited by divers.

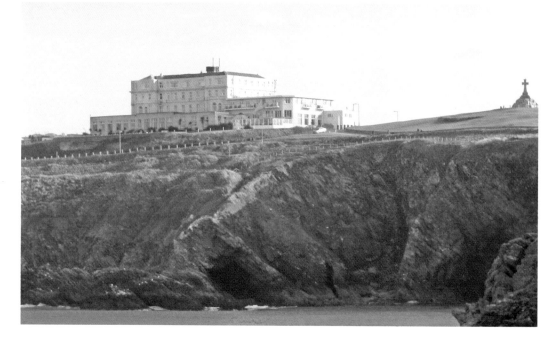

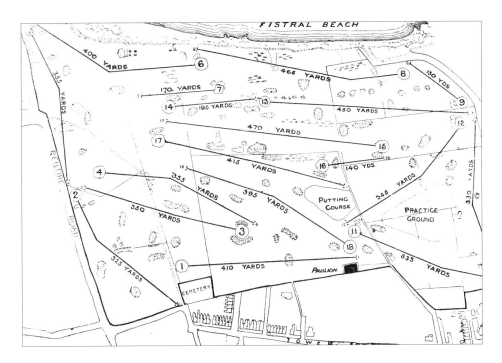

Fistral Mine

Before 1912, E. J. Ennor drew the map of Newquay Golf Course. He was president of the Newquay Old Cornwall Society in 1935. Just under the 'I' of the words Fistral Beach is a dotted line forming a loop about midway between holes 6 and 8. This was the entrance to Fistral Mine. The mineral lode trended from north to west and lay beneath the sand dunes on which golf is played even today. In 1845, the mine produced 75 tons of rock, containing 60 per cent of silvery galena. Bits of galena can still be found in the paths around the golf links.

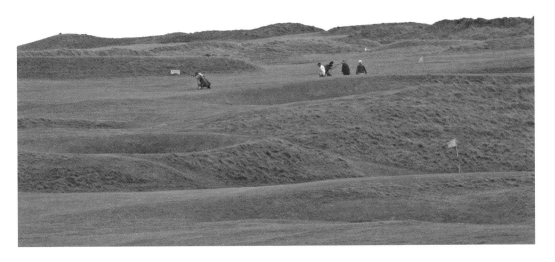

Lifeboats & Coastguards

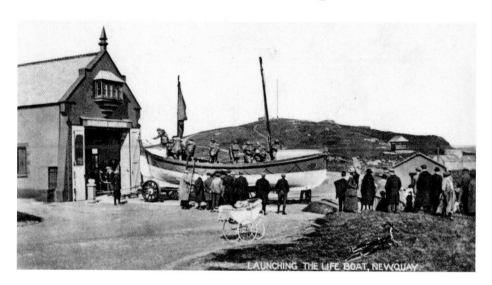

LAUNCHING THE LIFE BOAT, NEWQUAY.

Lifeboat Houses

Newquay has had three lifeboat houses. The newest is on the harbour. The first house was in Fore Street, which today is a shop called 'sunnydays'. The lifeboat was hauled to its destination by heavy horses and they did not like backing the vessel on its carriage into the little house. In 1899, a new boathouse was built on Towan Head, pictured here on Lifeboat Day many years ago. As there is now a lifeboat house on the harbour, this is no longer used.

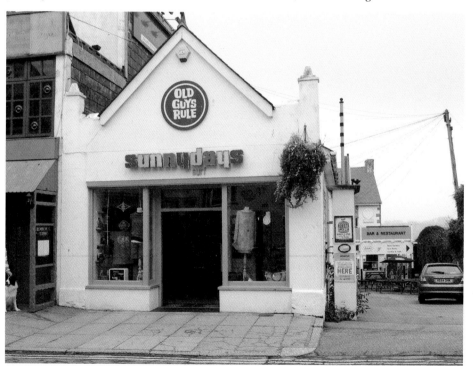

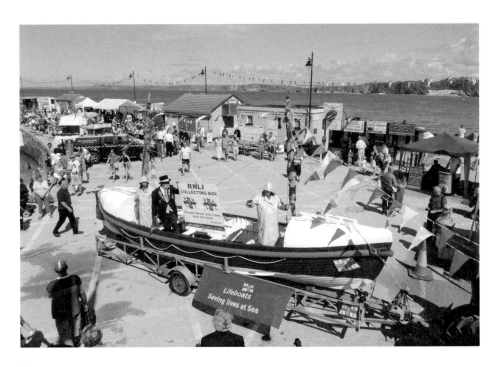

Lifeboats

The first lifeboat was the *Joshua,* which arrived at Newquay in 1860. Photographed is a replica used by RNLI volunteers for fundraising. This little boat is a complete contrast to newer vessels. Today, we have two lifeboats that home at the harbour: the *Valerie Wilson* and the *Gladys Mildred.* Pictured here is the *Valerie Wilson* on Lifeboat Day in 2013. The crew are demonstrating resuscitation of a victim in the water.

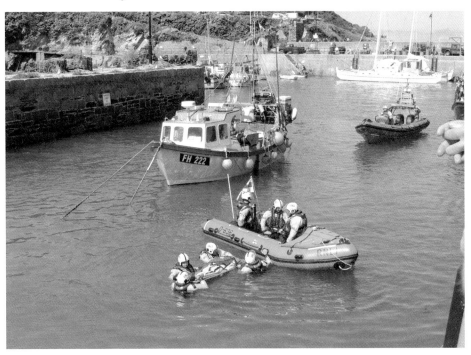

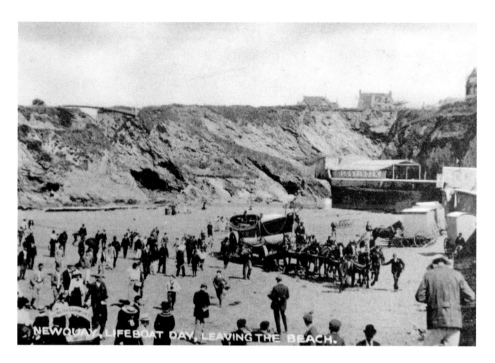

NEWQUAY LIFEBOAT DAY, LEAVING THE BEACH.

When the Boats Come Home

The lifeboat was launched off Towan Beach. It was taken down there on a carriage pulled by horses. The boat had to be manhandled off the carriage into deep and likely rough water. This was a hard and difficult job. When the boat returned, it then had to be put back on to the carriage and hauled off the beach. This was strenuous work for the horses as well as the men. The horses got stuck in sand, as did the carriage wheels at times. A specially adapted tractor, which can go into the sea, is used today as demonstrated on Lifeboat Day in Newquay Harbour.

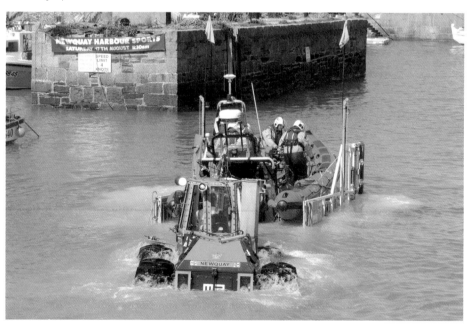

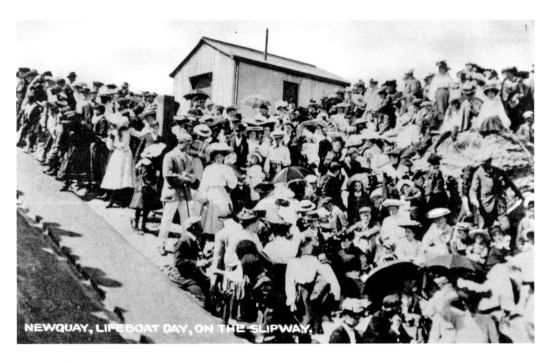

NEWQUAY, LIFEBOAT DAY, ON THE SLIPWAY.

Lifeboat Day

An annual day out, causing lots of excitement, was to watch the launch of the lifeboat. By 1895, Newquay had a slipway out on Towan Head to make getting the lifeboat into the sea much quicker. The slipway was the steepest in Britain, with a one in two and a quarter gradient. In 1899, the Towan Head Lifeboat House was opened. Today, Lifeboat Day is held in the harbour with demonstrations of rescues off the South Quay in the bay.

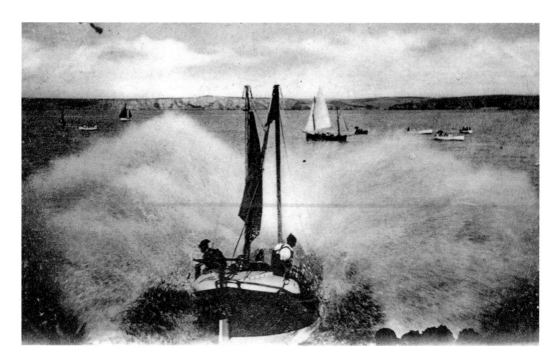

To the Rescue

I wonder what speed the old lifeboat was travelling at when launched off the slipway at Towan Head in the past? It made a great splash when it hit the water! Attending Lifeboat Day in 2013, I watched the helicopter performing different tasks. The man being winched up by the search and rescue helicopter, from RNAS *Culdrose*, had previously been dumped in the sea. All the time, the movement of the helicopter rotor blades churned up the sea and the engine noise was deafening. All very stirring.

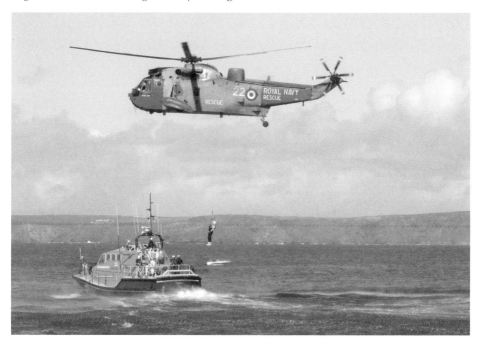

The Coastguard

In the nineteenth century, the job of the coastguard was to look out to sea for ships in trouble and summon help. The lookout in Newquay was on the Beacon near Towan Head. In 1825, a coastguard station and terrace of whitewashed cottages was built for the use of the coastguard and their families in Fore Street. This was the first terrace built in Newquay. Wilfred J. Lukes wrote a book about his memories called *Old Newquay*. His grandfather was station officer. A new lookout post was erected on the end of Towan Head. Mr Luke recalls being told by the old gentleman that many times when the weather was really bad, grandfather had to crawl from the little bridge by the lifeboat house to the top of the slope to the look-out. Then he had to begin his six-hour shift. The coastguard cottages were where the car park in Fore Street is next to the first lifeboat house. West End Bowling Green is on the site of the gardens.

Newquay Hotels

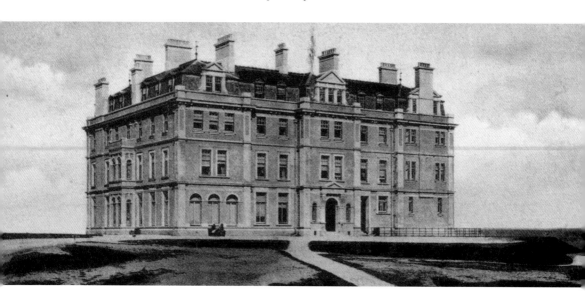

The Atlantic Hotel

Designed by Silvanus Trevail, Cornwall's most famous architect, the Atlantic Hotel opened to guests in 1892 in 10 acres of land on the Beacon near Towan Head. The hotel boasted stunning sea views from every window and all amenities, including a motor garage. It had electric light and a lift. As with other hotels in Newquay, the hotel has been expanded upwards and outwards with an adjacent building containing the swimming pool and poolside bedrooms. In 1967, The Beatles stayed there for three nights on their *Magical Mystery Tour*.

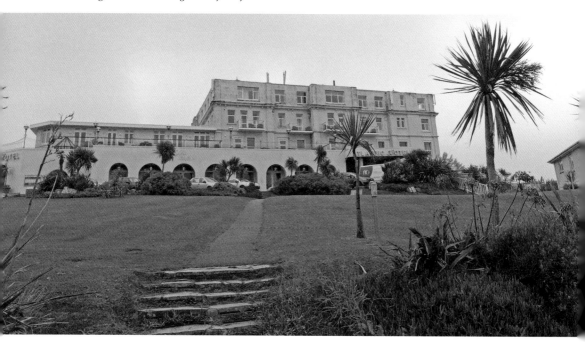

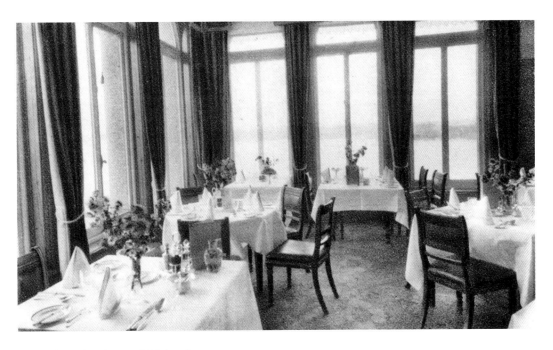

The Atlantic Hotel Dining Room

What a contrast for day-to-day dining at the Atlantic Hotel! The only similarity is the views of the sea from the windows. Enjoying an excellent cup of coffee sitting in a comfortable chair, I did admire the elegant décor in the now titled Silks Bistro & Champagne Bar.

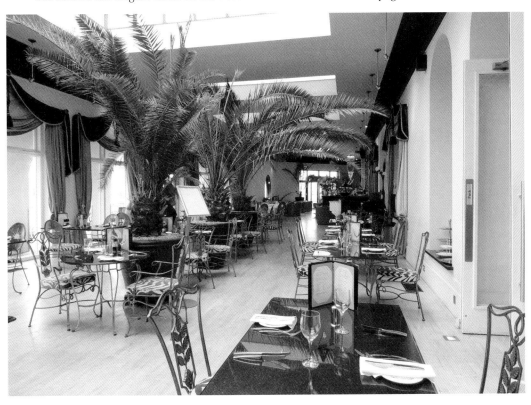

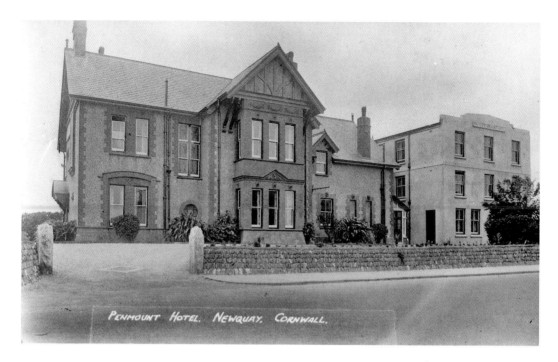

PENMOUNT HOTEL. NEWQUAY. CORNWALL.

Penberthy House

The Penmount Hotel became Penberthy House, a care home for the elderly. I wonder if the name was changed from Penmount to Penberthy because Penmount is the name of the nearest crematorium to Newquay and really would not be appropriate. Whenever there is a financial crisis, the holiday industry suffers. In the present economic climate, some local hotels are being converted to flats and houses.

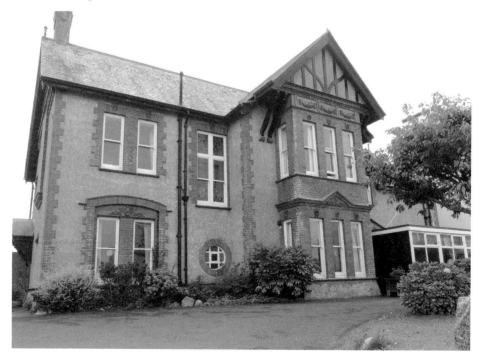

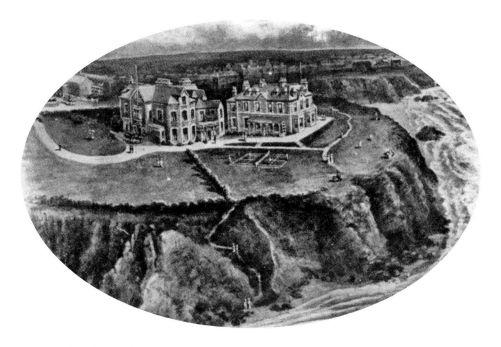

The Beachcroft Hotel

Originally the Beachcroft was two houses. One was the Cliff Garth built for Revd A. H. Molesworth St Aubyn by 1896. In 1912 the houses were being advertised as the 'Beachcroft Private Hotel'. There was a private path down to the beach and croquet and tennis courts. In 1927, the houses were joined together. Eventually, the hotel fell foul of the credit crunch and was demolished. Travelodge and Aldi eventually bought the site and opened for business in 2009.

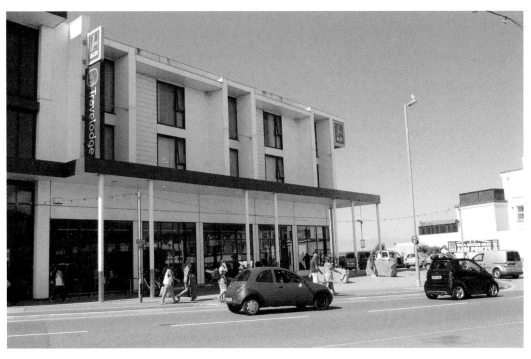

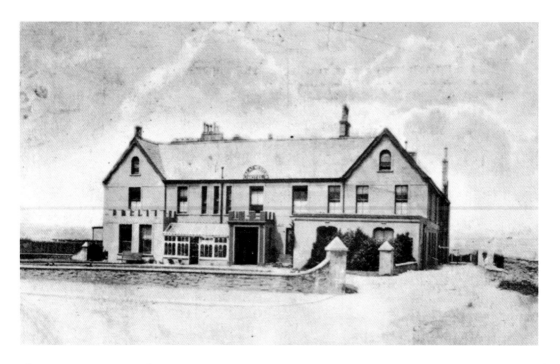

The Great Western Hotel

The coming of the passenger railway to Newquay brought more visitors, so what better than to have a hotel directly opposite the railway station in Cliff Road? It was built for J. H. Whitfield and the picture shows the hotel when it was his in 1905. In 1909, the first of three generations of Hoopers took over as proprietor. In 1985, St Austell Brewery took over the property and spent £1.1 million refurbishing it in 2007.

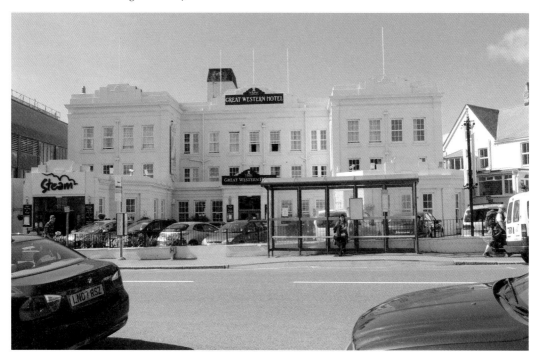

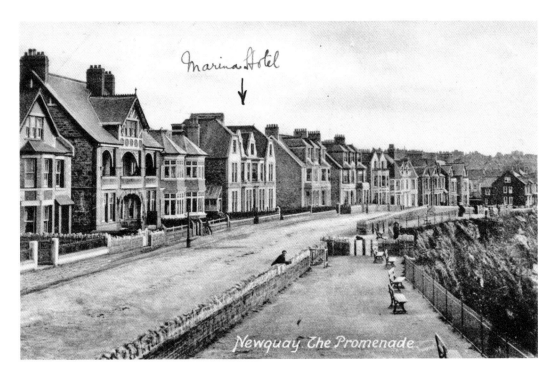

Marina Hotel ↓

Newquay The Promenade

Cliffdene Hotel

On Narrowcliff overlooking the Great Western Beach, Tolcarne Beach and Lusty Glaze was a series of very nice houses with gardens. Slowly, they were bought up and turned into hotels. The Cliffdene is one of these. If you look at the old photograph, taken around 1900, you can still make out the original homes. The Cliffdene still retains its pretty façade with balconies.

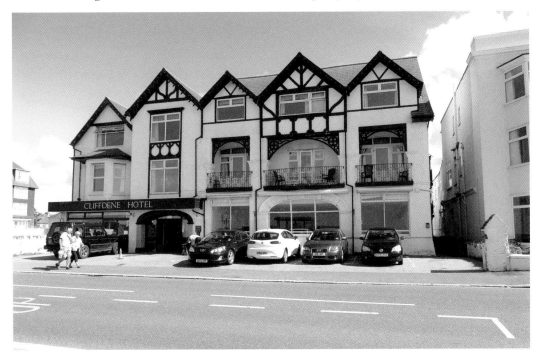

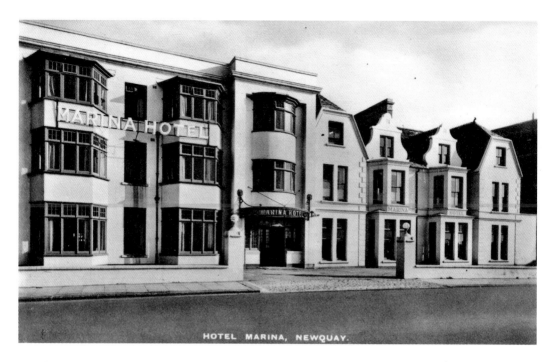

HOTEL MARINA, NEWQUAY.

Hotel Marina

The original hotel around 1900 only consisted of two houses next door but one to the Cliffdene Hotel. It was the same in 1912 when the proprietress was Mrs Beswerthick. By the 1950s, it looked very much like it does today. One of the side effects of all the expansions of Newquay's hotel buildings, upwards as well as outwards, was that much work was made for builders, plumbers, carpenters and other tradesmen.

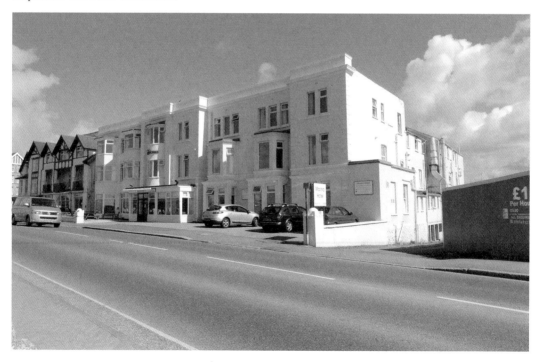

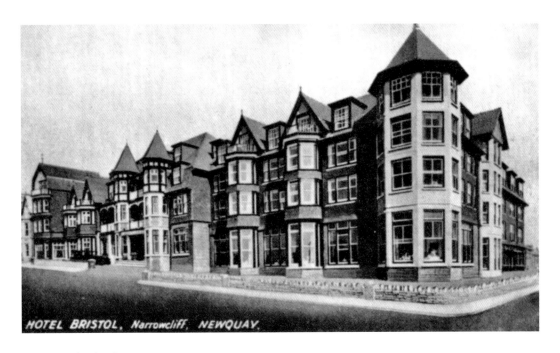

HOTEL BRISTOL, Narrowcliff, NEWQUAY.

Hotel Bristol

Eighty-six years ago, Mr and Mrs Young acquired Newquay College on Narrowcliff and opened the Hotel Bristol. It was so popular that they were able to expand either side of the old private school, including building on land where the Hotel Edgecumbe had been. This hotel was destroyed in a fire in 1919. The only casualty was a guest who jumped out of the window, breaking an ankle. Hotel Bristol is still run by descendents of the original Young family. The hotel today looks very much the same as it did in the 1930s. It keeps a high standard and even has facilities to charge up electric cars!

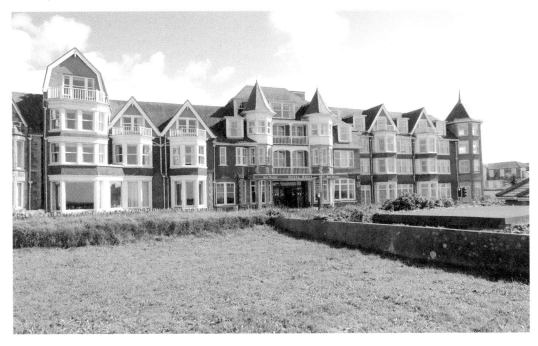

Glendorgal

On its own private headland, Glendorgal has access down to Porth Beach and views over Lusty Glaze. As with other hotels in Newquay, it started out as a gentleman's seaside residence. It did not become a hotel until 1950 when celebrated local author Nigel Tangye inherited it. It even had its own Bronze Age barrow in the grounds near the house, which was finally excavated in 1957. It was then discovered that there was an early Iron Age house abutting the barrow. In an advertisement for Glendorgal in the *Newquay Urban District Council Holiday Guide*, there is a note underneath that reads 'Nigel Tangye, the much travelled proprietor, directs Glendorgal in the Continental manner'. Nigel Tangye died in 1988. With new owners, the Glendorgal site has been expanded greatly.

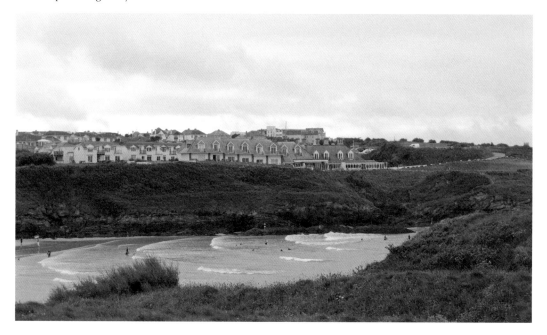

Manor Hotel
Originally, its front door overlooked Manor Road, but today this is in Marcus Hill as the hotel changed use many years ago. Today, it houses the council offices, including the council chamber and the local One Stop Shop where 'customers' can get advice on housing, council tax, benefits, refuse, recycling and all manner of other things. It also houses the tourist information centre.

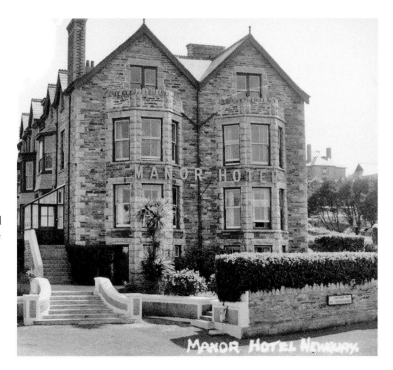

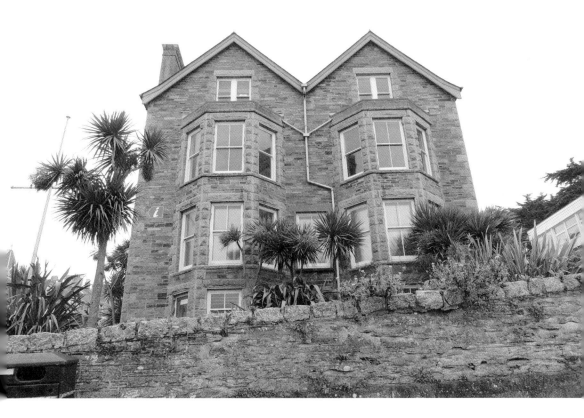

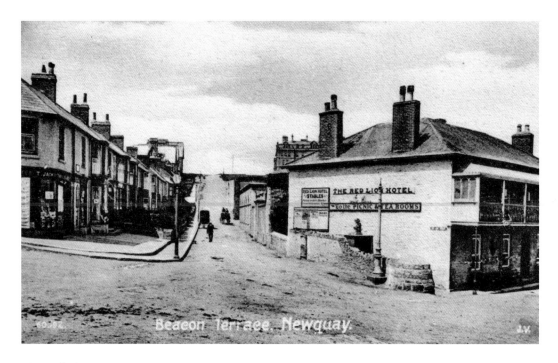

The Red Lion

Now Beacon Road, Beacon Terrace leads up to the Atlantic Hotel. Long before the Atlantic was built, the Red Lion was in existence. Dating from 1835, then a hotel, it had stables at the back, which are now accommodation. Today, it is a popular public house with superb views over Newquay. In the older photograph, taken around 1900, on the left is Thomas Jacka's grocer's shop, which was also a post office and today is a shop selling surfing equipment and clothing. James Elliot, a Victorian painter, lived at No. 17 Beacon Road.

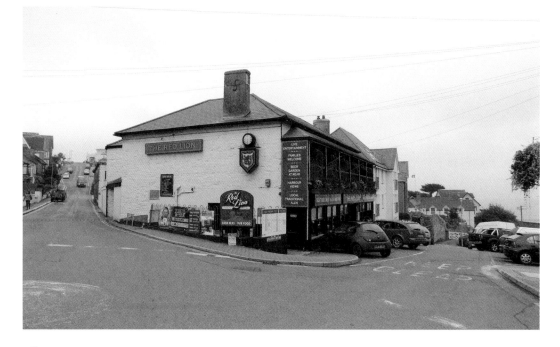

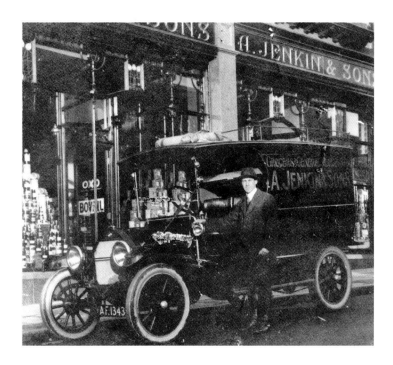

A. Jenkin & Sons

Standing by his delivery van is Harris Jenkin. The store in Fore Street, started by Capt. Frederick Jenkin, sold groceries, provisions, china and glass. Originally a smaller shop, after 1909 property next to it was acquired by the son of Capt. Jenkin and the store was revamped and the clock tower and lovely curved glass windows added. Now clothing shops and a betting shop occupy the space. Capt. Jenkin was a master mariner. The coaster *Treffry*, the first vessel built at Quay Yard by John and Martyn Clemens at Newquay Harbour in 1849, was initially owned by him.

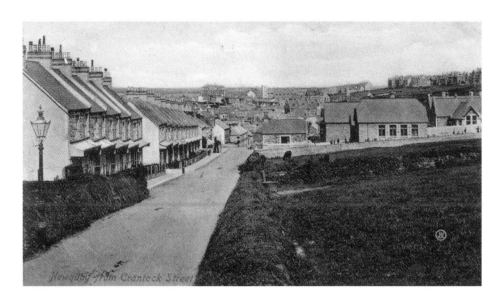

Crantock Street

On the right just beyond the green can be made out a small building, which was the fire station. In 1906, Mr Vivian was Captain of the Fire Brigade. During the Second World War, on 23 April 1941, there was a terrible German bombing raid on Plymouth. The Newquay wartime fire crew went to assist and were killed as they got to Plymouth. Of nine men, all volunteers, five died. These were G. Cameron, E. Old, B. Phillips, S. Vineer and F. Whiting. On the same site as the fire station was Newquay Board School. The school for girls was opened in 1875 and has now been replaced by Treffry Court. A boys' school was further up the road. In the modern picture on the left centre can be seen the hipped roof of what was Madame Hawke's knitting factory, which employed as many as 450 women and girls. Adjacent to it was the Mogford Box Factory, the cardboard boxes used for packing the articles made next door. Both buildings are now housing. Girls from all around Cornwall who worked for Madame Hawke stayed in boarding houses around town, including the Manor Hotel at Marcus Hill. Crantock Street is a very old byway leading over the ridge to Trethellan Hill, and thence across the River Gannel to Crantock.

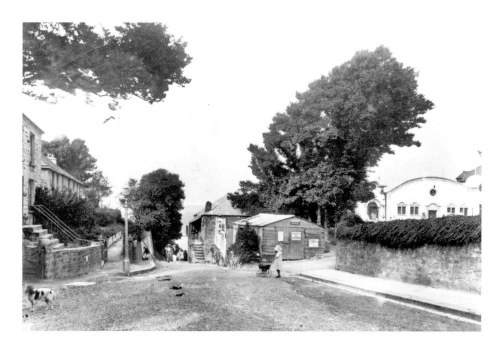

Beach Road

Leading down to Towan Beach, the Pavilion Theatre, on the far right, was built in 1912, later becoming the Camelot Cinema. Today, Walkabout is on the site. The little building with the steps at the front was Steps Malthouse, demolished in 1922. After being a malthouse, where barley was steeped in water till it germinated and then dried to be used in making ale, the property had various uses, including being a school and a band practice room. Beyond was the Unity Fish Cellar. The fish cellar companies were called Seanes or Seines, both spellings being acceptable. In 1837, the Unity Fish Cellar Accounts show the fishermen – sixteen seaners – got 9s each per week. The Master Seaner and the Huer earned 14s weekly. There were also bills for sustenance at business meetings. Over £22 was spent on public house costs. A further 6 gallons of rum, 4 gallons of gin and a 2 guinea cask of porter was purchased for use by Unity Sean that year. The fish cellar site is now a car park.

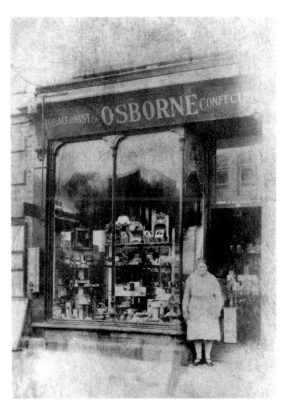

No. 14 Bank Street
Shoe Zone, which was Oliver's shoe shop in recent times, covers Nos 12 and 14 Bank Street. Osborne's Tobacconist and Confectioners was formerly Hawkens, which was a draper's shop.

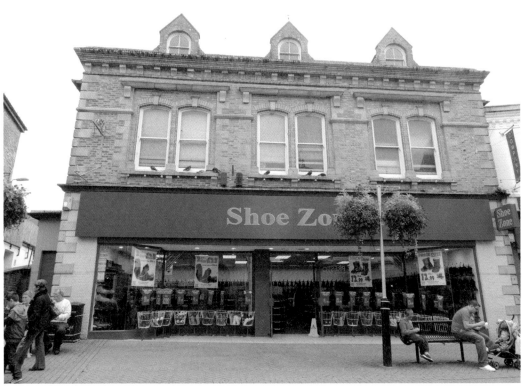

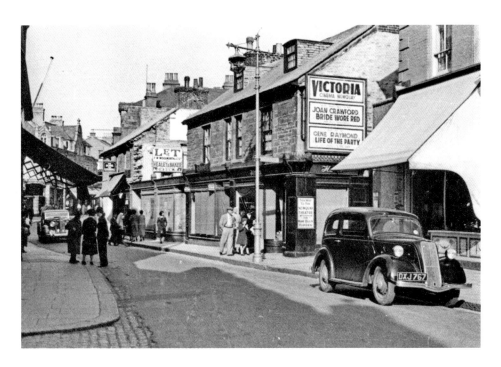

Nos 30–32 Bank Street

Clinton Cards today is the building on the site of the shop boasting a poster advertising 'The Bride Wore Red' for the Victoria Cinema. The cinema was behind the Central Inn. The film came out for showing in 1937, which dates the older photograph. The old chapel of ease, demolished in 1938, was on the back of the site Poundland is now on. Poundland and Peacocks (not shown) next door replaced Woolworths, which bought the chapel site.

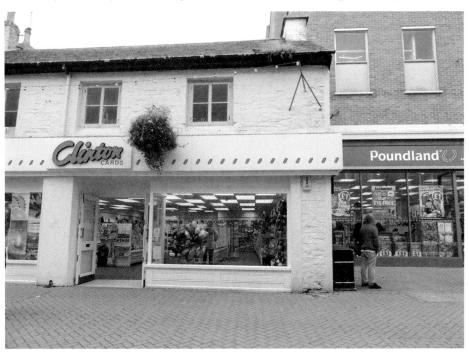

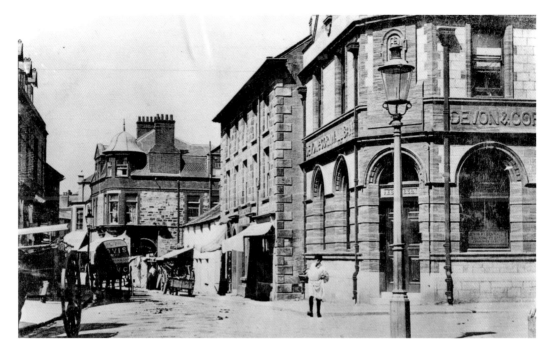

No. 31 Bank Street
The Devon & Cornwall Bank was designed by Silvanus Trevail and built in 1901. It became Lloyds Bank in 1906, and by 1910 Madame Hawke had a knitted goods shop there. In more modern times, it was a shoe shop and is now Costa coffee. Sadly, the date plaque above the doorway has gone.

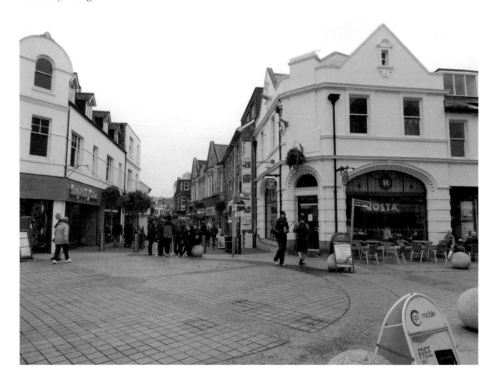

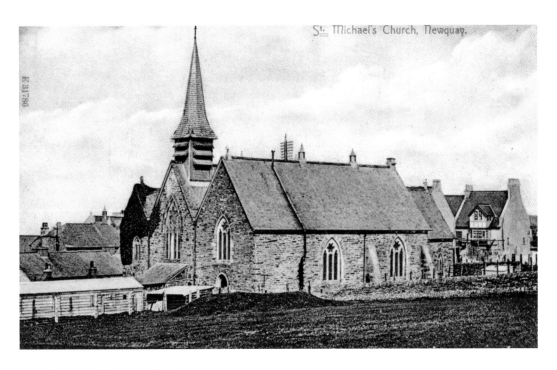

Chapel of Ease, Bank Street

The building of the chapel of ease off Bank Street was the fruition of much hard work by the Revd Nicholas Chudleigh. He laid the foundation stone in 1858 and the new church opened in September of that year. As Newquay grew, despite north and south aisles being added, it got too small and in 1911 a much larger church was built at Marcus Hill. In 1922, the chapel of ease was acquired by the Women's Institute, who sold the site to Woolworths. In 1938, it was demolished.

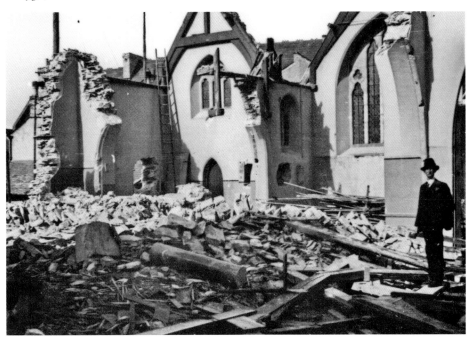

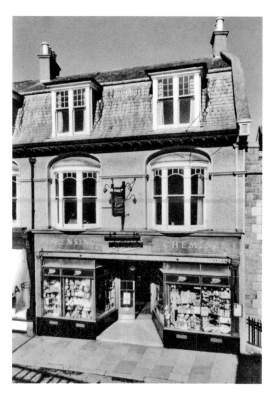

No. 45 Bank Street

Next to the United Reform church in Bank Street was Boots the chemist. Boots came to Newquay in 1930. They took over one of Alfred Bond's chemist shops, seen here in earlier days. It later became Timothy White's hardware store and then a clothing shop. It was Foster's selling menswear until 2012, when it was taken over by the Blue Inc. company.

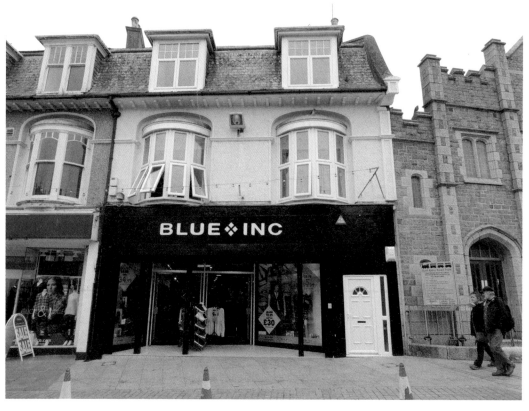

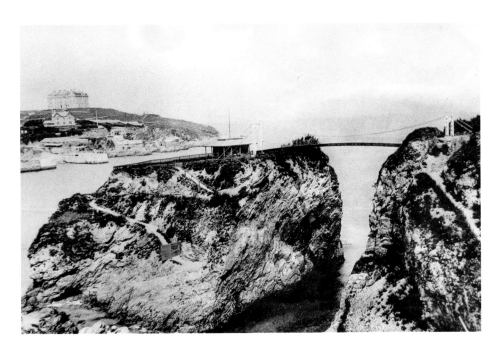

The House by the Sea, Towan Beach

When the Manor of Towan Blystra was sold in 1838, William Billings acquired a lease on the island for ninety-nine years. He had a garden there for growing vegetables. Now known as the 'Island in the Sea' (for marketing purposes, no doubt), eventually there was a summer house on the island. The bridge was built around 1902. It was said to have been commissioned by Sir Thomas Henry Hall Caine, a Manx man and a writer of romantic novels. He was secretary to Dante Gabriel Rossetti at one time. The home we see today was built *c.* 1930.

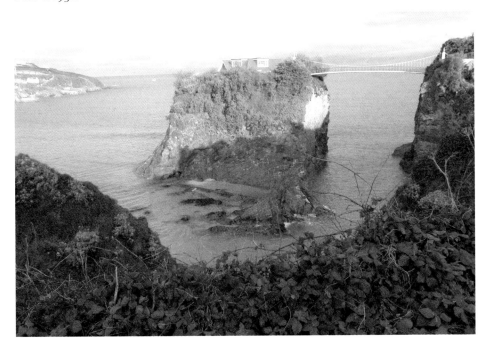

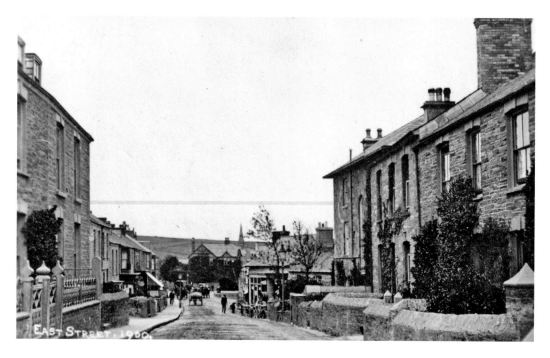

East Street

In 1900, looking down East Street, there is a view of fields in the direction of the far end of Mount Wise and East Pentire, serving as a backdrop to the spire of the chapel of ease. The carriages in the road are being driven over the set of tramway rails linking the harbour to the railway station. On the left is E. J. Powell's cycle shop, just this side of the establishment that has its window blind pulled out. On the right, where Slots arcade is today, was H. Garlick & Sons, a painters and decorators, and next door to it in 1915 was Coombe's, a drug store. At No. 15 East Street, where Andy's Café, Bunters and Flounders now grace the frontage, was Madame Brouscelle & Co., where art and needlework were sold.

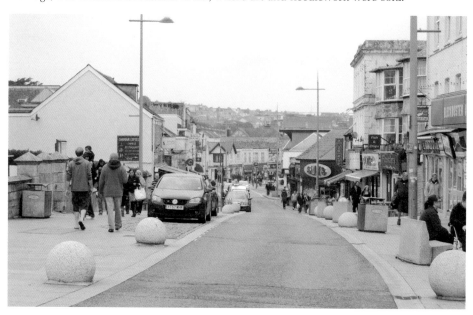

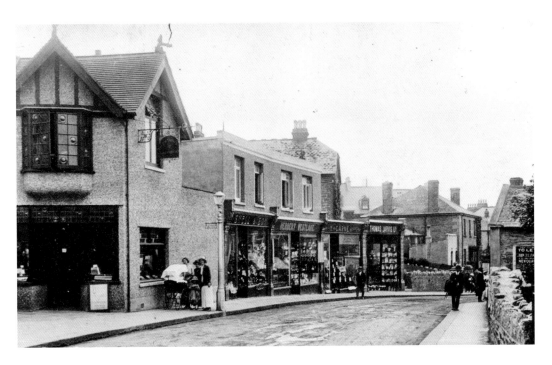

Looking Down Bank Street from East Street

The distinctive building, front left in the old photograph from *c.* 1930, was the tourist information centre. In 1915, it was the shop of H. G. Slee & Co., who also had Tolcarne Nurseries. Next door is Snell & Sons, bootmakers, then Herbert Westlakes, which was an ironmongers, followed by T. Carne Outfitters and Thomas Jarvis's China and Glass shop. Most of this block is now Hunters, selling sweatshirts and hoodies and such like. On the right is the wall of the garden of Chymedden, where Dr Hickey lived. This is now the site of Barclays Bank.

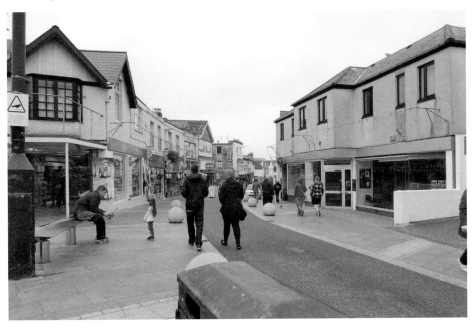

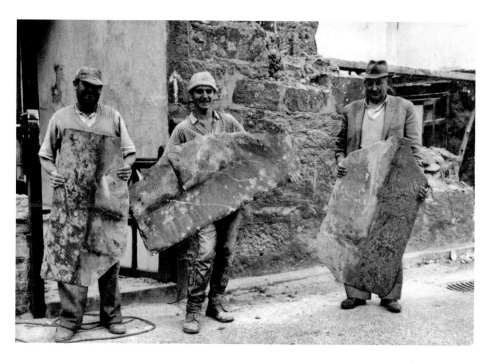

Changes Around Newquay

When Newquay was the Manor of Towan Blystra, consisting of a few houses dotted around Central Square and a little fishing harbour, St Columb Minor was the main village in the area. Slowly, Newquay has spread and now both settlements run into each other. Developments and changes in the area have been continual since the early 1800s and are still ongoing. A cottage in St Columb Minor is being demolished in 1964. Borthalan, at No. 31 Mount Wise, opposite the top of Marcus Hill, was taken apart in 2011.

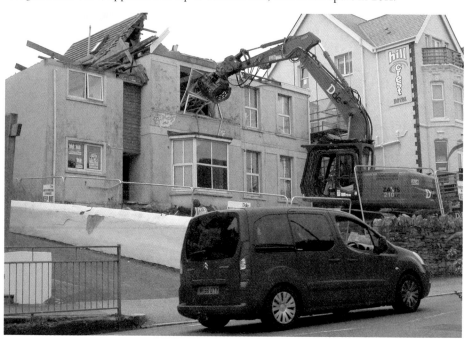

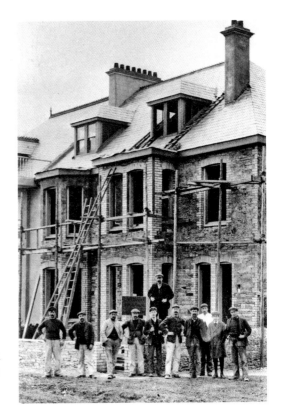

Changes Around Newquay

The National Children's Home, Pentire Crescent, was built in 1918 and closed around 1962. It became the Tregarn Hotel and was eventually demolished. Recently, sixty-four residential apartments have been built on the site. Borthalon on Mount Wise is now called Ocean View and has luxury holiday flats for rental.

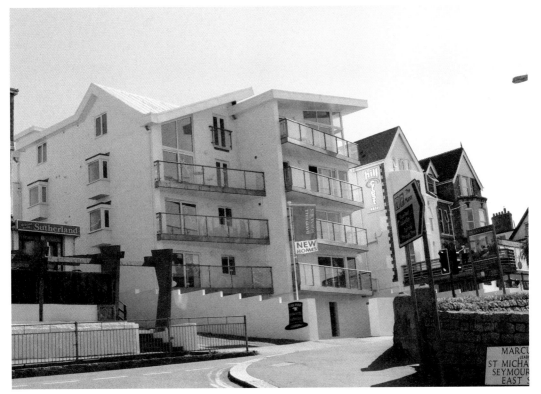

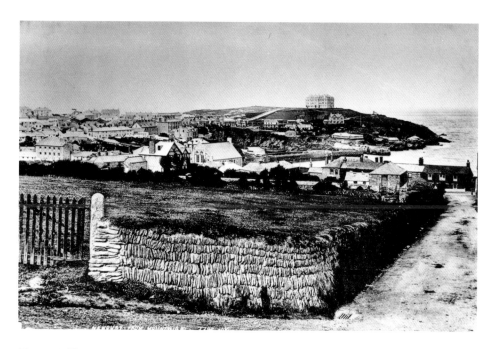

Marcus Hill

Slowly, Newquay was spreading. In 1900, from the top of Marcus Hill, we could view the Atlantic Hotel and the harbour. From right to left around the harbour, we would see the Fly, Good Intent and Active Fish cellars. Looking further left, one could pick out the row of five whitewashed coastguard houses and washing hanging out in their long gardens in Fore Street. Now, from the top of Mount Wise, we can still see the Atlantic Hotel and just make out the harbour, but St Michael's church and the council offices block out the rest of the scene.

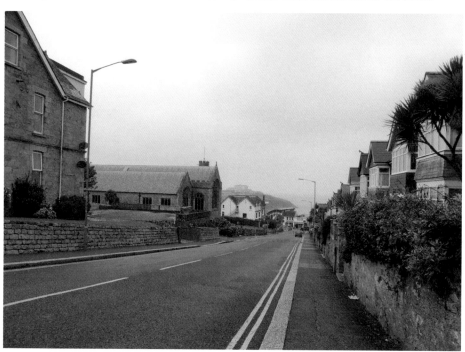

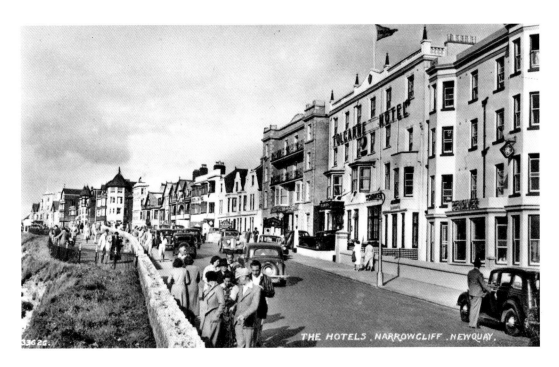

Narrowcliff

The most dramatic change along Narrowcliff is the demolition of St Brannocks and the adjacent Tolcarne Hotel, c. 2009. The site at present is a car park. The Marina Hotel beyond St Brannocks has undergone a facelift since the older photograph was taken c. 1950.

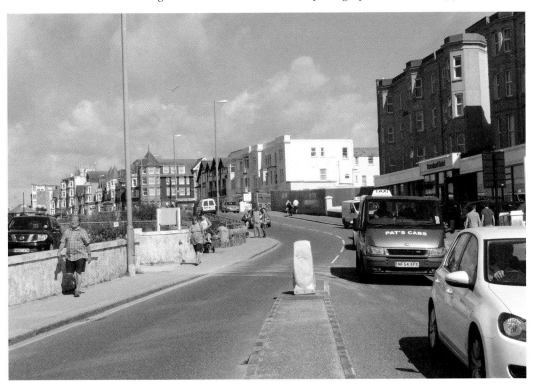

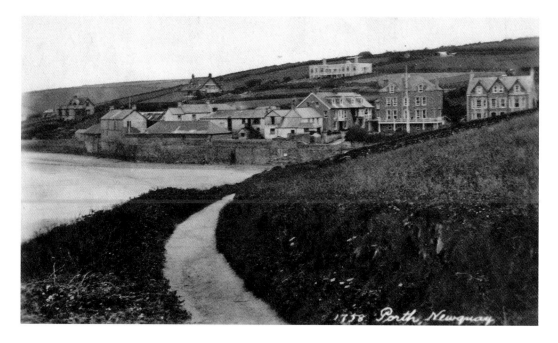

Porth

To think of the seaside resort of Porth today as an industrial area is difficult. Yet here, before the 1900s, there was shipbuilding, brickworks and quarries, limekilns, and a fish cellar. In the older photograph, we see a long retaining wall at the back of the beach. On its far right end was a lime kiln demolished around 1956. Following left, we see a long shed right against the wall. This was where coal was stored, brought from Swansea by ship. Alex Stephens was the coal merchant and a ship owner. Limestone was also brought into Porth. Behind the coal sheds are other buildings, including a pilchard works. This was sited over two fields: Sleemans and Cellar Close. In 1803, twenty-four adventurers got together to form the Concord seine on the fields. In 1821, the worldly goods Samuel Martyn left to his two sons included a dwelling house near the beach, a malthouse, limekiln, coal-bank, fish cellars and the lower part of Sleeman's Close.

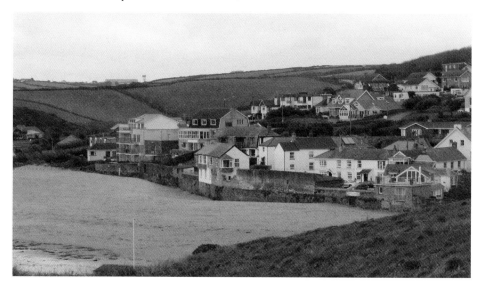

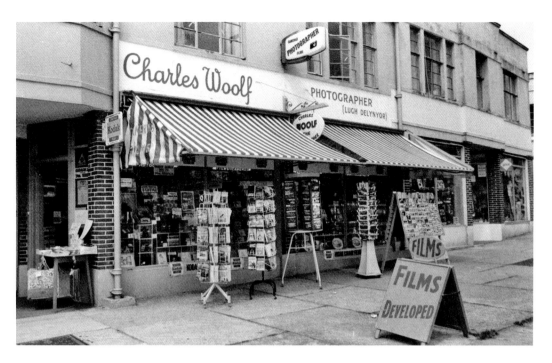

Chester Road

Charles Woolf's photographic shop in Chester Road, pictured in 1972, is now Bed-Times. Mr Woolf had previously worked for Boots in Bank Street, Newquay, as a pharmacist. He and photographer Joyce Greenham, who worked with him at Chester Road, were responsible for acquiring many of the pictures now in the Newquay Old Cornwall Society archive. Among the many posts she held, Miss Greenham was the society's archivist for many years, and without her work many of the photographs in this book would not be accessible.

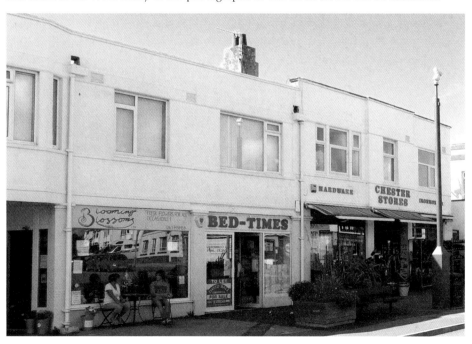

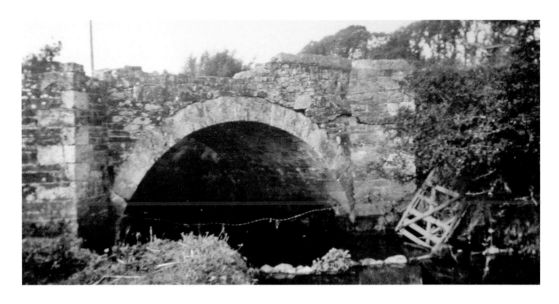

Trevemper Bridge, 1955

Before the Trevemper Road was built alongside the River Gannel, the only way out of old Newquay from the settlement around Central Square, if one wished to go down the county, was either by fording the River Gannel or by taking the track leading from Berry Road out of the village, where East Street and Cliff Road meet. One went up Berry Road then over Trenance Hill, across a ford at the bottom of it, thence up Treninnick Hill, which leads into Treloggan Road. At the T-junction at the top of this road, one turned right and went down what is now the A392. Eventually, one would have to cross Trevemper Bridge, pictured here in 1955. This was a tiny packhorse bridge. It has been damaged many times over the centuries. Around 1925, a larger bridge had been built roughly parallel to it, and in 1939 the county council wanted to close the old one. The war intervened and the bridge remained there. In 1978, Charles Woolf, then president of the Newquay Old Cornwall Society, wrote to the Highways Department of Cornwall County Council and asked, as road improvements at Trevemper were being carried out, could not the packhorse bridge be repaired for the use of pedestrians and thus save a bit of Newquay's heritage? This was done.

Trevemper Bridge and Mill

Sadly, a fire destroyed buildings at Trevemper Mill in 1963. Most literature dates Trevemper Bridge back to the 1600s. In fact, there has been a bridge at Trevemper certainly since *c.* 1240. It is mentioned in the will of Maud Maunsell. She left Sir Ralph de Arundel land in the Manor of Treninnick and a moor on the side of Trevemper Bridge in the vill of Treninnick. In 2010, the author, as Local Warden of Ancient Monuments for the Newquay Old Cornwall Society, formed a group to assist her in her post. This includes clearance work of 'monuments' around Newquay. The first job the group did in March 2011 was to tidy up Trevemper Bridge. Since then they visit the site as required to keep it from getting overgrown.

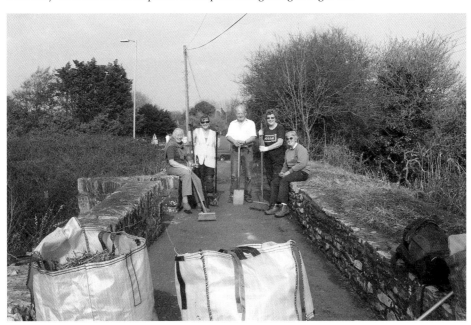

Transport

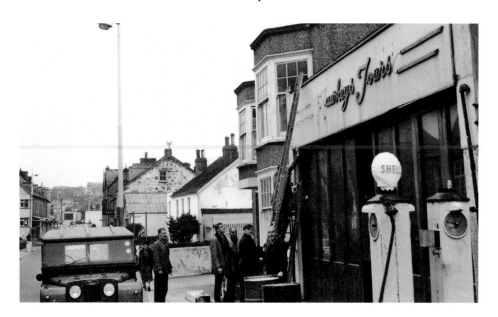

Hawkey's Tours

With the increasing popularity of Newquay to visitors, coach companies sprang up running tours around the county. One of these was Hawkey's Tours. They had a garage in Fore Street and appear to have had trouble with the garage signage when this picture was taken in 1958. The Hawkey's Tours booking office was in East Street where the Cornwall Hospice Care charity shop is today. The company folded over twenty years ago. In 1915, Arthur Hawkey was a coach builder at No. 64 Fore Street.

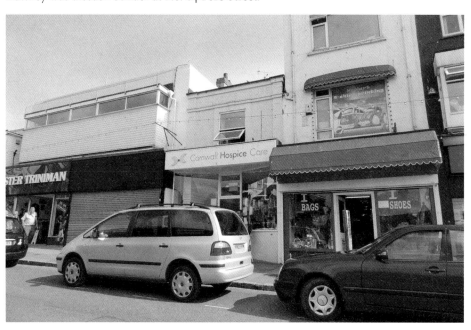

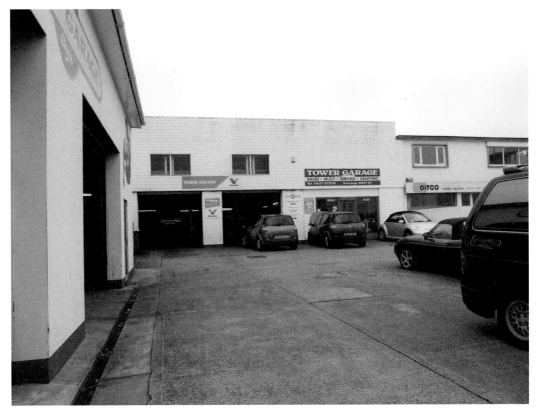

Tower Garage

With the coming of the motor car and motorcycle, garages were needed to provide fuel and repairs. Today, at the junction of Hope Terrace and Tower Road, is Tower Garage. It is built on the site of Hope Fish Cellar. In 1873, George Burt leased a parcel of land to the Hope Seine Fishing Company with rights to build a sufficient cellar and loft with lookout accommodation. During the Second World War, there was a British Restaurant at the garage.

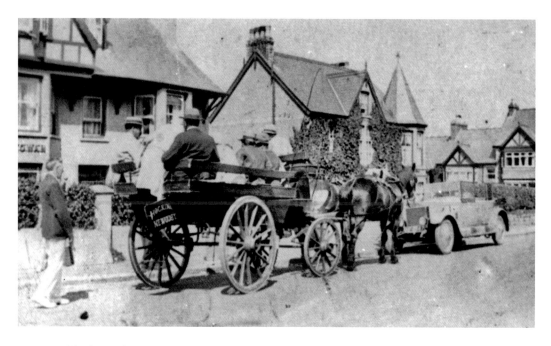

Hocking's Carriage

In the 1903 *Kelly's Directory* of Newquay, Mrs Hocking of No. 10 Railway Terrace and, by 1915, at No. 20 East Street, is listed as a jobmaster. This involved providing horses and carriages for hire. The 'Hocking of Newquay' horse and carriage pictured will be taking the passengers for a tour when they are all aboard. They are being picked up outside their accommodation in Mount Wise. The house on right is where Dr Chambre Corker Vigurs lived. He died in 1940. He was a medical doctor and his rounds included Newquay, Crantock, St Columb Minor and Colan. He was also a noted botanist and a major contributor to the 1909 Flora of Cornwall.

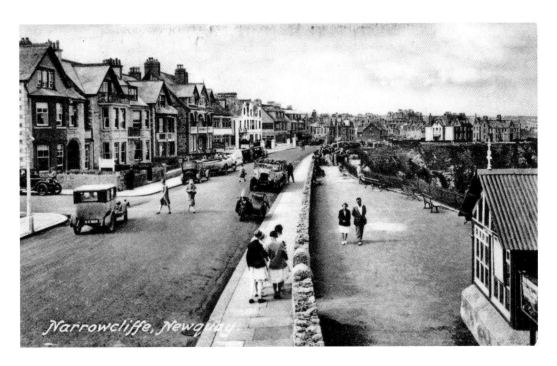

Narrowcliffe, Newquay

Buses and Charabancs

A view of Narrowcliff around 1935 shows two charabancs, one outside the Cliffdene Hotel and one on the other side of the road. Hotels could arrange for their guests to be picked up by companies organising excursions. The charabancs were open-topped coaches, so weren't comfortable for long journeys. They did have a canvas roof that could be pulled up if it rained. If it did everyone got wet, as putting the roof up took a bit of time. As a comparison here is a modern Western Greyhound bus at Manor Road bus station. The company run services out of Summercourt. Earlier in 2013 there was a terrible fire at the depot and about a third of the bus fleet was destroyed.

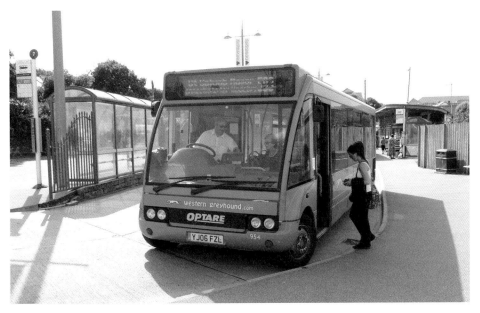

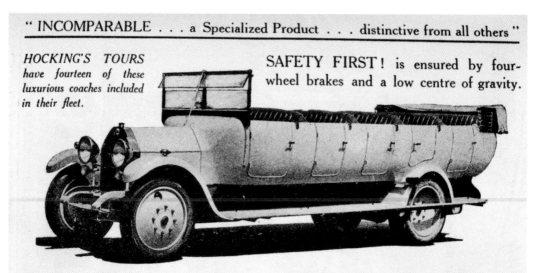

Hocking's Charabanc and the Road Train

Taken from an advertising brochure for Hockings that was printed around 1927, what a contrast the charabanc is to the road train that takes people around Newquay today. Made in Italy by Dotto, the road train is the Muson River design, with four-wheel drive and a diesel engine. You can hop off and on where you like for one fare. Its route begins outside the United Reform church in Bank Street.

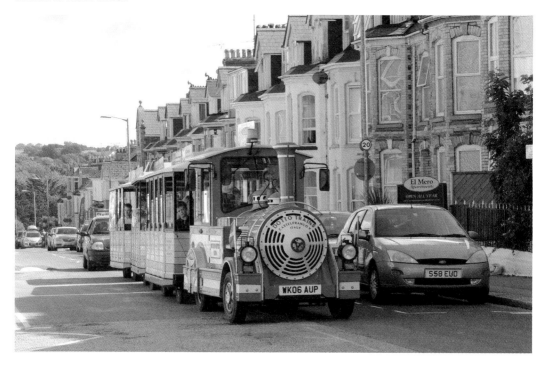

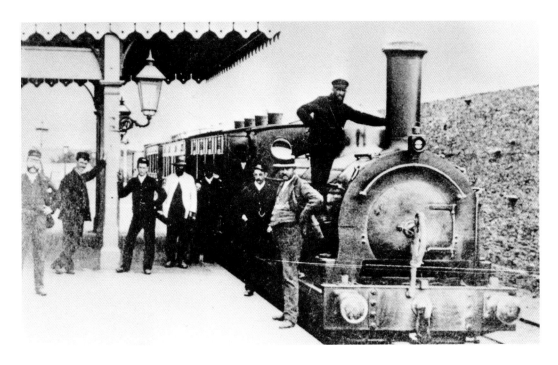

Trains

The first passenger train to run from Fowey to Newquay did so on 26 June 1876. The service was run by the Cornwall Mineral Railway. They had extended the route of Treffry's original horse-drawn railway, which allowed clay and stone to be taken to Newquay Harbour by joining up the Newquay line with Treffry's Fowey to St Dennis Junction section. In 1889, the Cornwall Mineral Railways amalgamated with the Great Western Railway, and in time passengers could travel from London to Newquay by train. Today, on the single-track Newquay rail line, we have 'multiple unit trains', run by First Great Western, with a diesel engine in one or more of the train carriages.

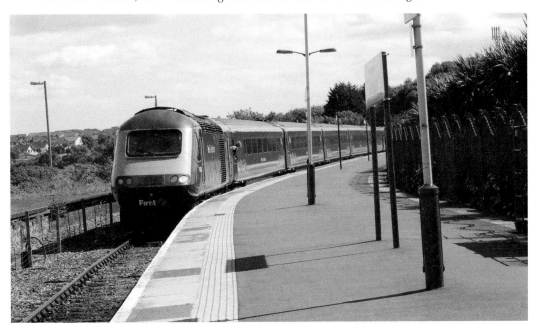

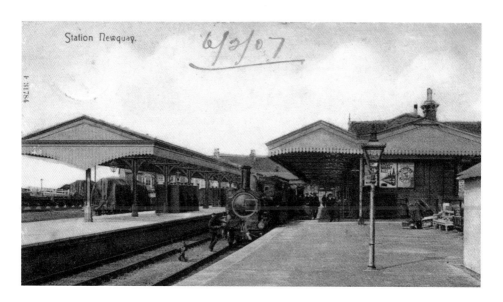

Steam at Newquay

The Cornwall Mineral Railway was amalgamated with the Great Western Railway in 1889. The Newquay to Par broad gauge line was converted to standard gauge by 1892. By 1902, GWR built a new double engine shed and an extra platform at Newquay to take local branch line trains. Diesel locomotives were introduced in the late 1950s. On 6 September 2011, a rare event took place at Newquay railway station. A 70000 *Britannia* came into Newquay, hauling carriages full of railway enthusiasts. The trip they were on involved travelling on several different steam trains from Waterloo to the resort. Due to many difficulties, in the end the 70000 had to make the whole journey assisted by a diesel engine. The sixty-year-old *Britannia* brought back many memories, especially when the driver covered everybody on the Newquay platform in steam before pulling out of the station.

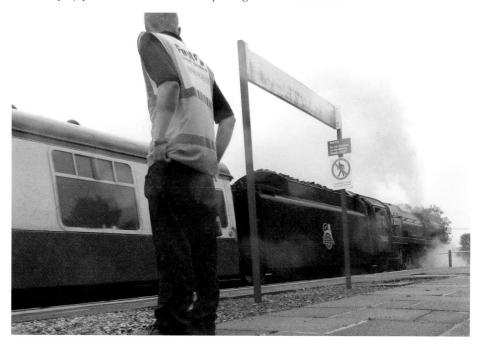

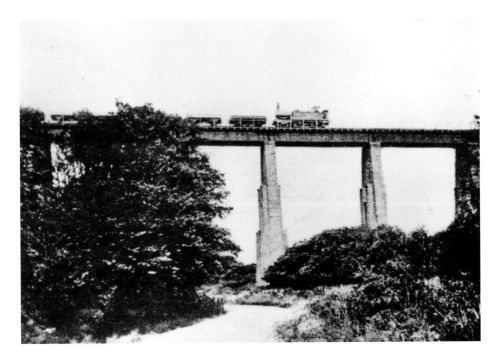

The Viaduct, Trenance Valley

Crossing Edgcumbe Avenue, in what was called the Tolcarne valley, was the original viaduct, built for Treffry, known as the Spider. It had granite pillars supporting a wood structure only capable of taking horse-drawn trucks. In 1872, it was replaced by Cornwall Mineral Railways with a more sturdy construction. In the photograph, there is a CMR 0-6-0T locomotive pulling empty clay wagons out of Newquay sometime before 1900. The modern viaduct we see today was built in 1939.

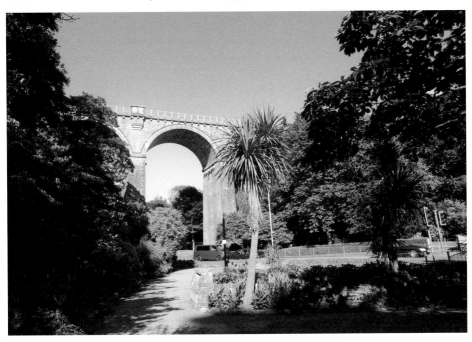

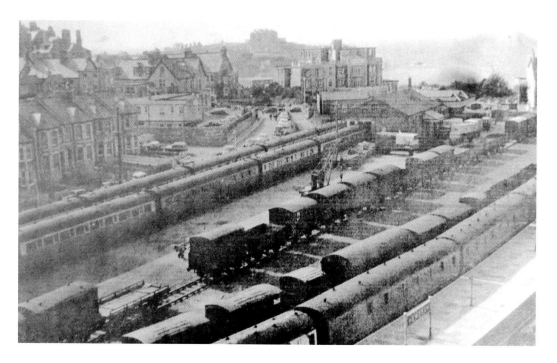

Newquay Railway Station

It is hard to believe that the single track station that exists now was once as busy as the late 1950s photograph shows. The railways had been nationalised in 1948 and began to lose money. By the 1960s, many lines were closed down. Through the 1960s into the 1980s, the Newquay goods yard sidings and all the platforms bar one were removed.

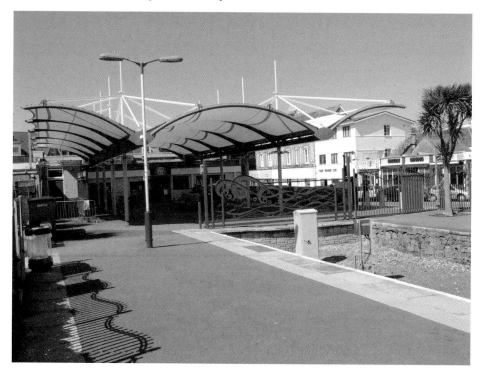

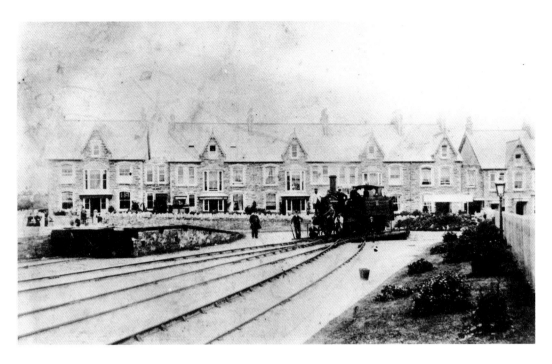

The Train Turntable

Around 1904, Newquay railway station underwent expansion, with two platforms and three tracks replacing the old single-rail line. The turntable across the road from houses in Cliff Road, which are now shops, was removed.

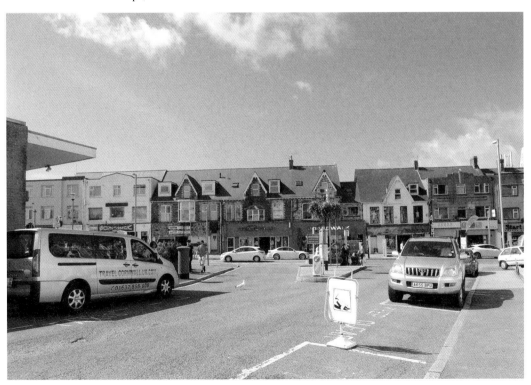

Celebration & Recreation

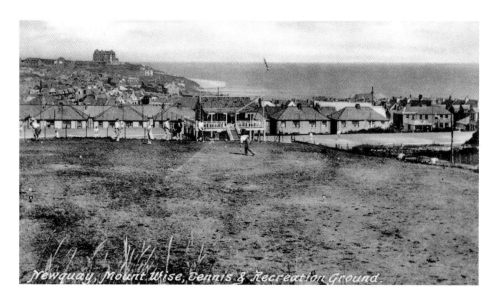

Newquay, Mount Wise, Tennis & Recreation Ground.

Mount Wise Tennis Courts

With the massive increase in the use of road transport after the Second World War, Newquay needed more and more car parks in town. So the tennis courts, which existed before 1912, below Mount Wise gave way to vehicles. Mount Wise is on a ridge running through part of town overlooking Newquay Bay. Around the 1900s, it was known as Lehenver Lane and people complained about the pot holes in it. The modern photograph shows the narrow Church Path, which runs down to the main shopping centre. It led to the Church of England chapel of ease in Bank Street, built in 1858 and dedicated to St Michael.

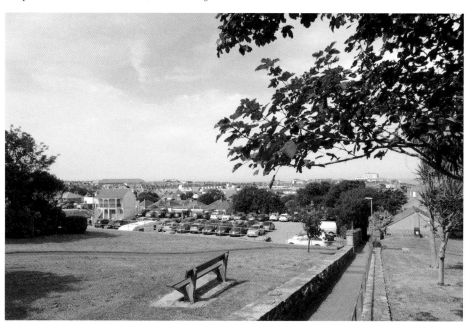

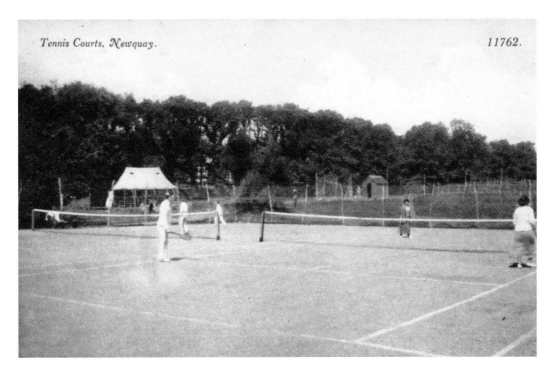

Trenance Gardens Tennis Courts

Still a popular game today, the tennis courts in Trenance Gardens are still there. Not many years ago, what appeared to be a huge inflated pillow appeared next to the outdoor courts. The pillow turned out to be a conference centre and indoor courts. Locals wait for this impressive structure to deflate, but this has not happened yet.

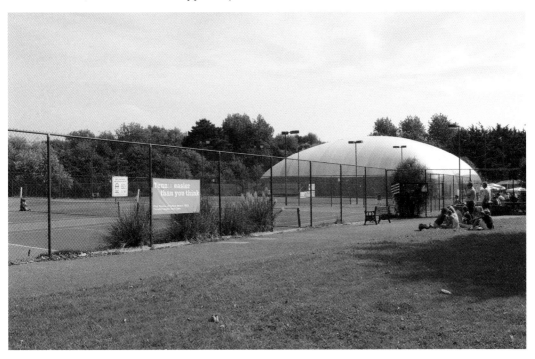

Newquay Golf Links

Situated overlooking Fistral Beach, with fine views of the ocean, the club was formed around 1890. Mr H. F. Whitefield, mine and property owner, was the first president. Their Royal Highnesses the Prince of Wales and Prince Albert spent a golfing holiday in Newquay in 1911 and paid further visits over the years. They were honorary life members. In 1912, membership of the club was 5 guineas entrance fee and 3 guineas annually. The Tower, built in 1835 for the Molesworth family, was acquired by the club in 1906 and is still used as the clubhouse. The links are built on the site of a lead mine, Newquay Consols, also known as Fistral Mine. In 1906, the caddies came out on strike as a notice appeared on the green discouraging golfers from giving them tips. The youngsters could earn at least £1 per week, which was probably more than their fathers earned for the same duration. The dispute was resolved when a policeman told the children that railway men weren't supposed to take tips either, but still got given gratuities. The caddies made good sense of this and went back to their duties.

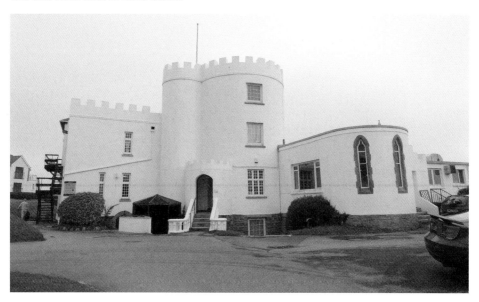

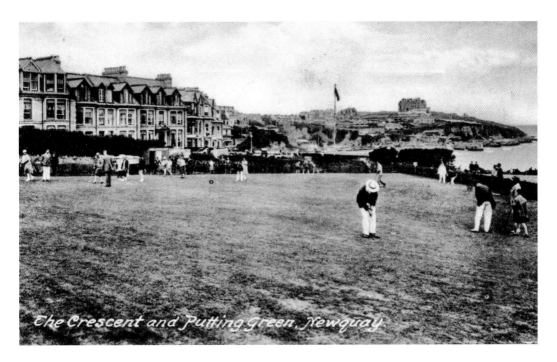

The Crescent and Putting Green, Newquay.

Putting at Killacourt

Backed by the Crescent, Killacourt overlooks Towan Beach. It is a venue for many activities, including modern and traditional concerts. In 2002, a large granite stone with a plaque commemorating The Beatles' visit to Newquay in 1967, when filming scenes for their *Magical Mystery Tour*, was unveiled.

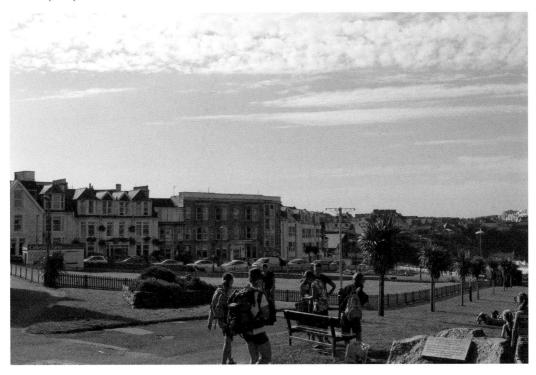

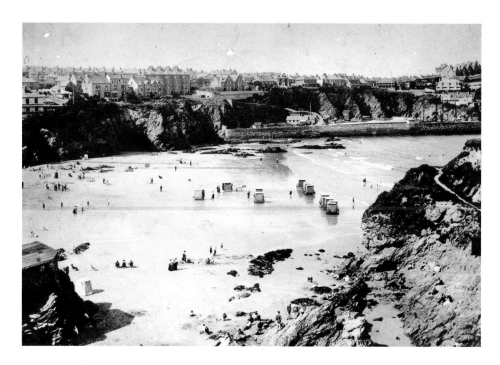

Towan Beach

Always a popular beach, the main difference between the Edwardian scene and now is the bathing machines and the much lesser amount of clothes worn by the holidaymakers. The bathing machines would be pulled by ponies to the sea edge as required. Inside, one would have changed into one's bathing costume. Once the machine was in place, one then dashed into the water, as the etiquette of the times demanded that little of the body be seen. This was particularly important for ladies. When the Gregor family of Trewarthenick came for their summer holidays, staying at the Tower, now the Newquay Golf Links clubhouse, they were preceded by their bathing machine being horse-drawn into town.

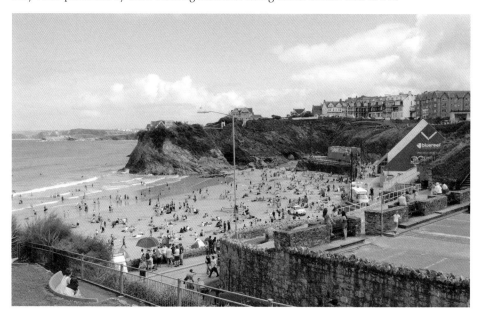

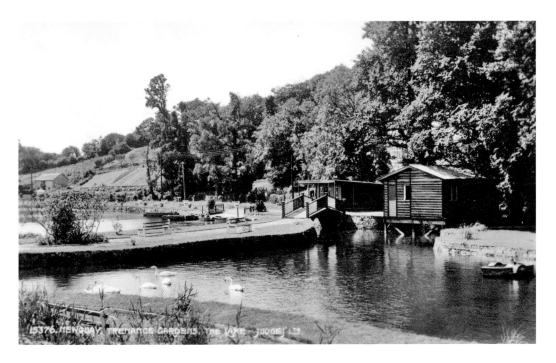

Trenance Gardens Boating Lake

The children's boating lake was equipped with little paddle boats *c.* 1950. Now this part of the gardens is given over to the swans and ducks. There is an island in that lake with nesting sites provided for the fowl so they can breed in peace. Off Trenance Lane, the road that backs the lakes, flats have been built and the two wooden cabins have been replaced by the excellent Lakeside Restaurant.

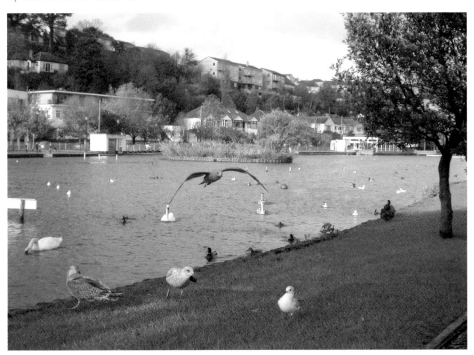

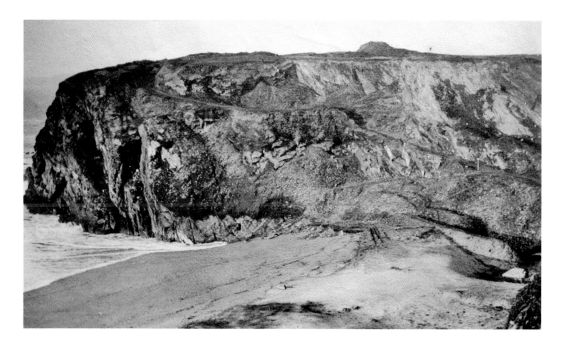

Tolcarne Beach

Crowned by one of three remaining Bronze Age barrows on the Barrowfields, the very old view of Tolcarne Beach shows the path down to the sands. This ran by a quarry where there is now a crazy golf course. At the back of the beach in the cliff are still adits from lead mining. The mine was shown on a map in 1839 and was called Wheal Narrow at that time. Around thirty years ago, a specimen of boleite crystals, a rare secondary mineral containing lead, silver and copper, was discovered in an accessible mine adit at the back of the beach. Rockfalls these days can contain pyromorphite, a lead phosphate. The beach looks much friendlier now with its tiers of multi-coloured beach huts.

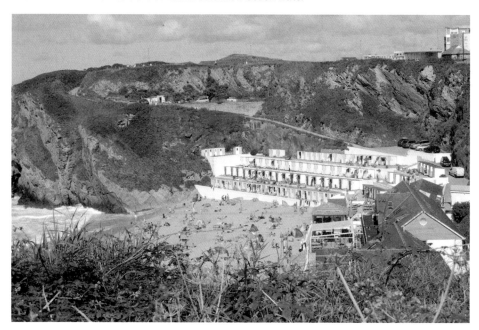

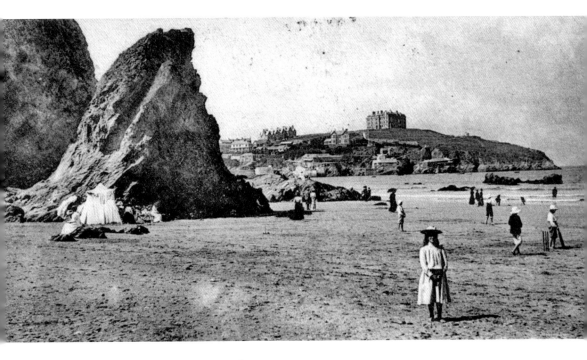

Bishops Rock, Great Western Beach

A young lady stands primly on Great Western Beach near to Bishops Rock. The rock looks very much the same today as it did in 1904 when the postcard was sent from Bertie to a young lady. What would she think of the modern surfers in the water?

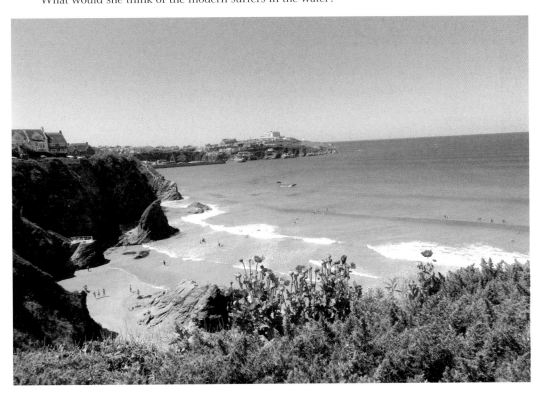

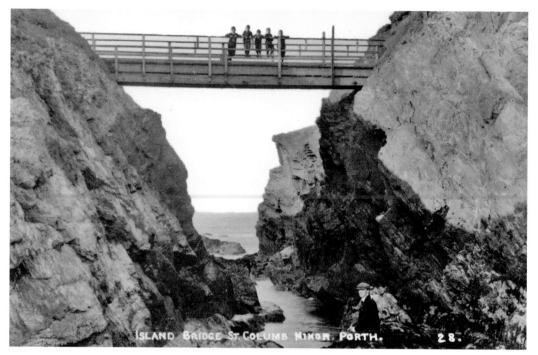

ISLAND BRIDGE St. COLUMB MINOR PORTH. 28.

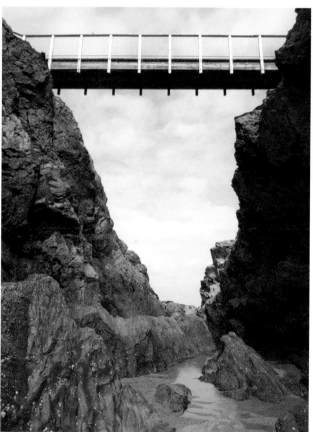

Porth Island Bridge

Before *c.* 1912, to get to Porth Island (Trevelgue Head) from Newquay one had to walk to Porth and cross the river that runs down onto Porth Beach and thence up onto the headland. This was only possible at low tide. Then, around 1912, a road bridge was erected at the back of the beach across the flowing waters, and one no longer got ones feet wet! The bridge suffers from the weather and has been replaced a number of times. It crosses a chasm that, when viewed from above at low water, one can see a ledge on one side. In this are carved two pools, which may have been used for storing lobsters, crabs, or shellfish.

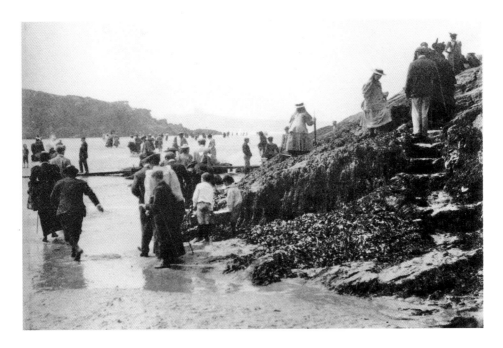

The Cavern Concerts

In the 1920s and 1930s, concerts were held at very low tide in a cave called the Banqueting Hall. The cave was on Whipsidery Beach on the mainland side of the Porth headland, near the Porth Island bridge. The best way to reach the cave from Newquay was by using steps cut by Sir Richard Tangye on Porth Island and mainland near the bridge. This made access easier to the beach on the other side and the Banqueting Hall. The cave was blown up in 1987 by the English China Clay Company, as it was deemed unsafe by the local council. When it was being used for concerts a man used to test the safety of the Banqueting Hall using a huge tuning fork. The vibrations of the fork were meant to make rocks fall down in the cavern if any were loose. Some of the rock cut steps still exist today.

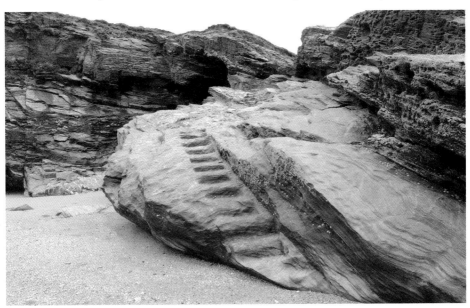

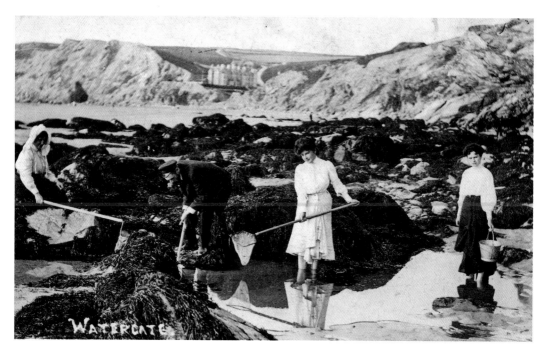

Fishing for Tiddlers

Watergate Beach is a long stretch of sand with rock pools, ideal places for fishing for tiddlers, shrimps and prawns in late Victorian times. There is another 'fish', though, that can be taken home, albeit in bits. The fossil remains of a species of Pteraspis can be found in the grey Lower Devonian slates exposed here and there in the cliffs at Watergate. In the photograph of the fossils, one can see bits of skin showing the internal honeycomb structure and spines. The 'fish' weren't really fish but precursors to animals with backbones. Pteraspis didn't have a spine, just a sort of stick called a notochord running up its back. Evolution was yet to allow it to develop a lower jaw, and fins were just projections of skin forming spines. It lived on the bottom of lakes and by waggling its body was able to make water and mud pass through it, containing organisms it could digest.

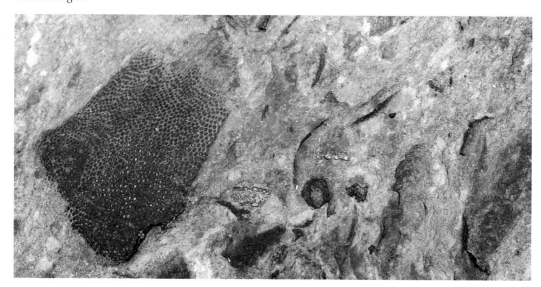

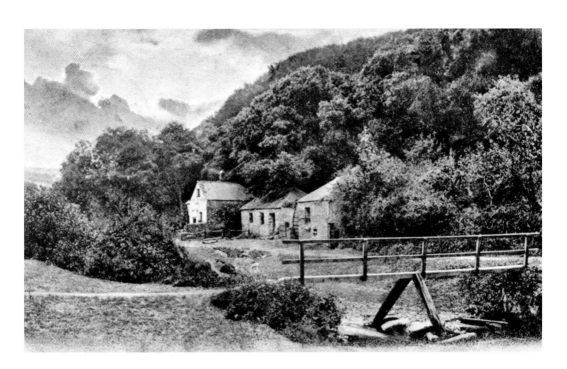

Lawrey's Mill, St Mawgan in Pydar

With the invention of the bicycle, people used to walk or cycle out to beauty spots, such as Lawrey's Mill on the Carnanton estate. In the 1911 census, the family living there were named Lawry. Sadly, in recent times, the mill has fallen into rack and ruin. The walk through Carnanton woods is still worth doing and dippers can be seen on the River Menalhyl.

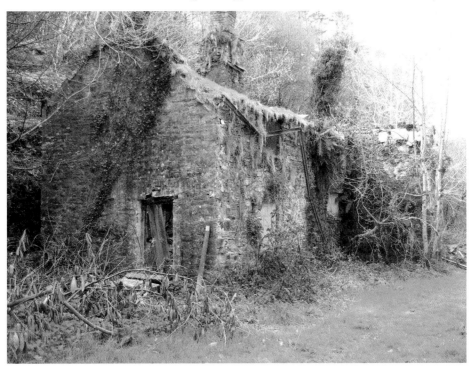

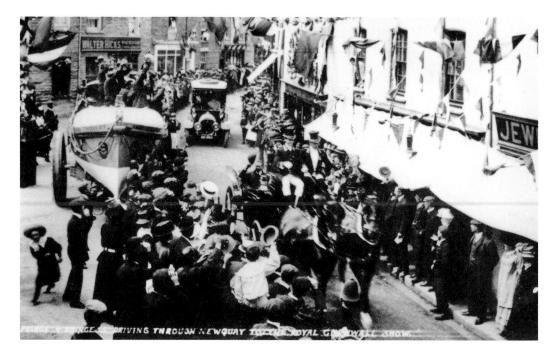

Commercial Square

The Central Inn, a modern watering hole for locals and visitors alike, used to be the Commercial Hotel. There was an inn on the site in 1755. Behind the crowd, next to the hotel, is Walter Hicks' shop. He was a brewer and wine merchant. The people in the square, as the title of the postcard says, are 'Greeting the Prince and Princess driving through Newquay to the Royal Cornwall Show'. This was the Royal Cornwall Agricultural Show in 1909, being held locally. These days, the show is held each year in June at Wadebridge, but up until *c.* 1960, it was held in different venues in the county. The first show was at Bodmin in 1793.

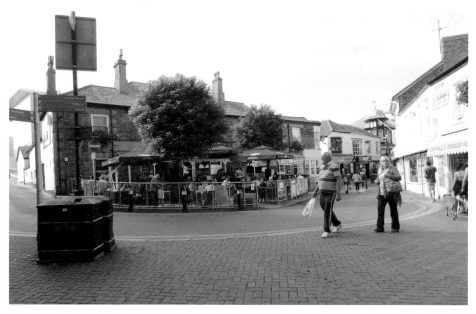

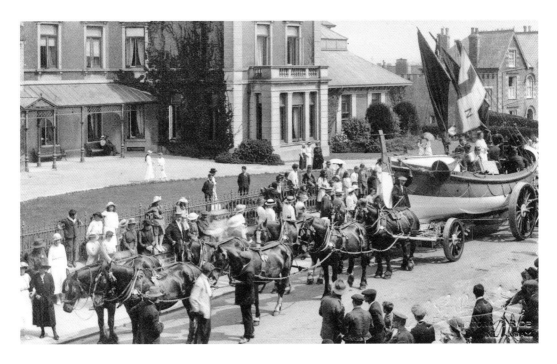

Lifeboat Parade

A parade through town was always a part of Lifeboat Day. The older photograph shows the lifeboat being taken past the Victoria Hotel in East Street in Edwardian times. There is still a parade held on the day and a much more dramatic event when the RNAS Search and Rescue helicopter, the *Gladys Mildred*, and the Tamar Class all-weather boat *Spirit of Padstow* processed across Newquay bay in August 2013.

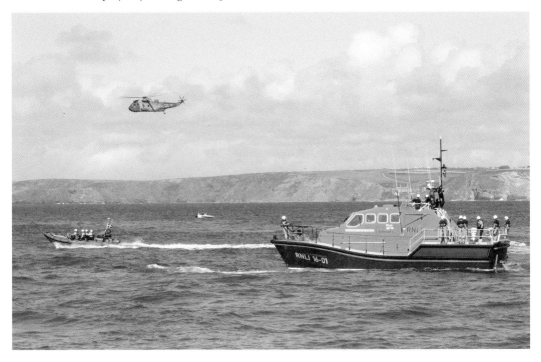

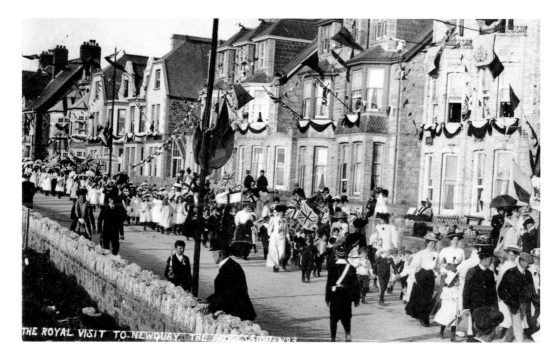

THE ROYAL VISIT TO NEWQUAY. THE PROCESSION N°3

The Royal Visit, 1909, and the Olympics, 2012

Whenever royalty visited Newquay, out came the bunting and the Union Jacks. The picture is probably part of the parade for the opening of the Royal Cornwall Agricultural Show in 1909. The parade is passing down Narrowcliff. The next best thing to a royal visit lately was when the Olympic Torch came to Newquay en route from Lands End to the opening of the Olympic Games in London. On 19 May 2012 at 1.55 p.m., the torch was exchanged at the corner of Berry Road and Mount Wise.

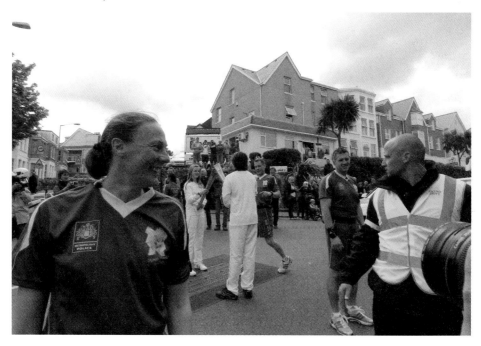

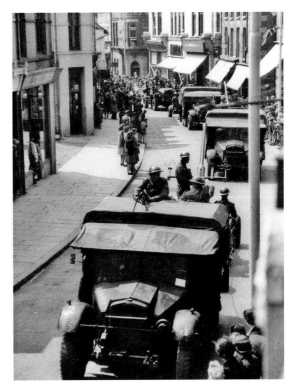

VE Day, 1945

To celebrate the end of the war in 1945 on VE Day, services were held in all the local churches. This was followed in the afternoon by a victory parade through town of those involved in the war effort. The parade was led by the town band. Pictured are forces personnel in their vehicles towing anti-aircraft guns through Bank Street. As part of the celebrations for the Queen's Diamond Jubilee, the rose garden at Trenance Gardens was given a facelift in 2012.

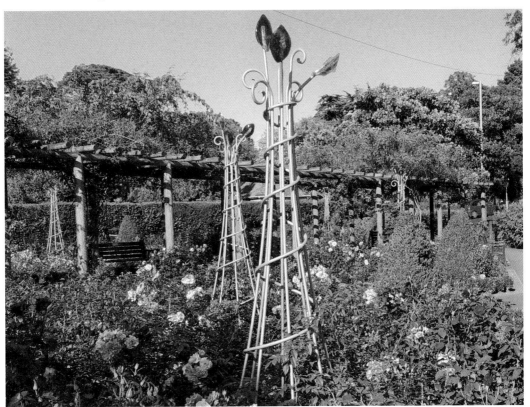

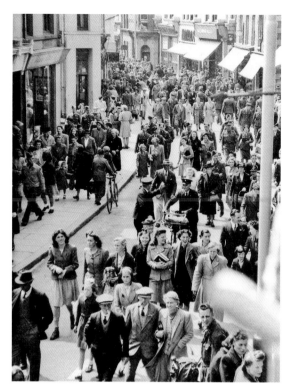

After the VE Day Parade
Comparing scenes of the crowd dispersing after the VE Day Victory Parade has passed through Bank Street with holidaymakers in 2013, the one thing in common is that a lot of people are smiling.

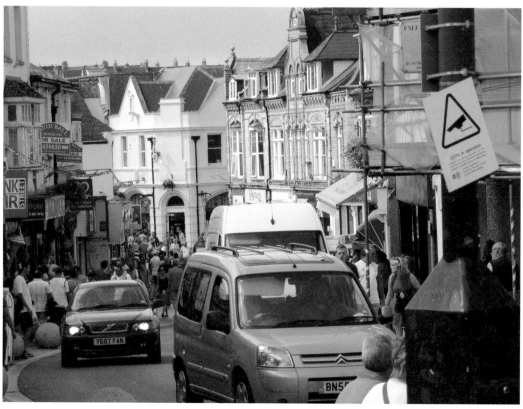

The Watch House

The Watch House, also known as the Round House, was built in 1833 as a lookout in case of enemy invasion and to spot smuggler's vessels along the coast. It had a weather vane on top in the shape of a ship. There was much opposition when it was demolished and replaced with the Newquay War Memorial. On the Beacon, looming over Fore Street, the memorial is a constant reminder of the loss of local people killed or missing in the last two world wars, and in the Falklands and Afghanistan. It was unveiled on 24 May 1921 by the then Prince of Wales.

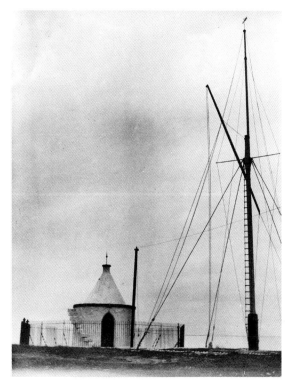

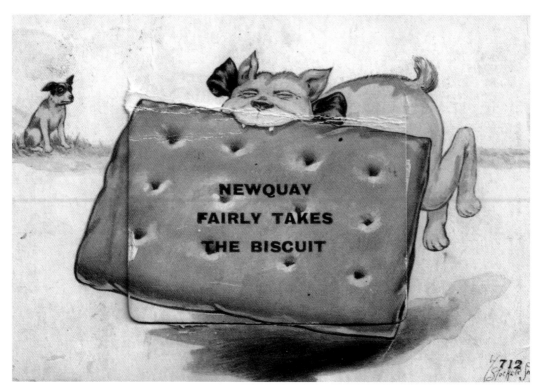

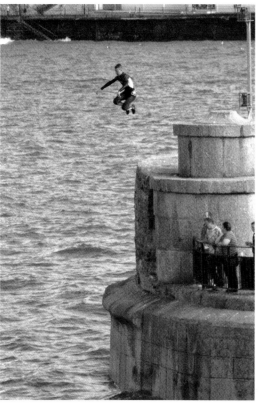

Newquay Fairly Takes the Biscuit

In 1925, a chap called Gordon sent the postcard featured here to a lady. There was no message as the wording on the front says it all. The resort of Newquay has something for everyone. From the young man jumping off the Harbour Light looking for a thrill, the families and the children building sand castles on the beach, the surfers, the golfers, the tennis players, the walkers, the hen and stag parties, fossil hunters and historians – Newquay has it all. As an end note, jumping off the Harbour Light has recently been banned. Discussing this with local lass, a child in the 1950s, she remembers doing the same. The children who hung around the harbour were called the Harbour Rats. And they had so much fun!